# SKETCH!

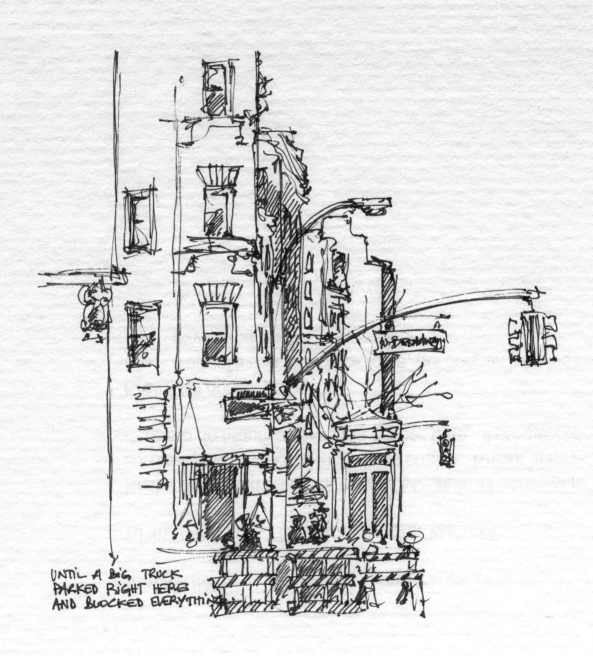

UNTIL A BIG TRUCK
PARKED RIGHT HERE
AND BLOCKED EVERYTHING.

# SKETCH!

France Belleville-Van Stone

WATSON-GUPTILL

BERKELEY

Published in the United States by Watson-Guptill
Publications, an imprint of the Crown Publishing Group,
a division of Random House LLC, a Penguin Random
House Company, New York.
www.crownpublishing.com
www.watsonguptill.com

WATSON-GUPTILL is a registered trademark, and the
WG and Horse designs are registered trademarks of
Random House LLC.

Library of Congress Cataloging-in-Publication Data
Belleville-Van Stone, France.
Sketch! / France Belleville-Van Stone. — First Edition.
    pages cm
1. Drawing—Technique. I. Title.
 NC650.B45 2014
 741.2—dc23

                        2014012253

Trade Paperback ISBN: 978-0-38534-609-2
eBook ISBN: 978-0-38534-610-8

Printed in China

Design by Michelle Thompson
Cover Design by Angelina Cheney and
Christina Jirachachavalwong

10 9 8 7 6 5 4 3 2 1

First Edition

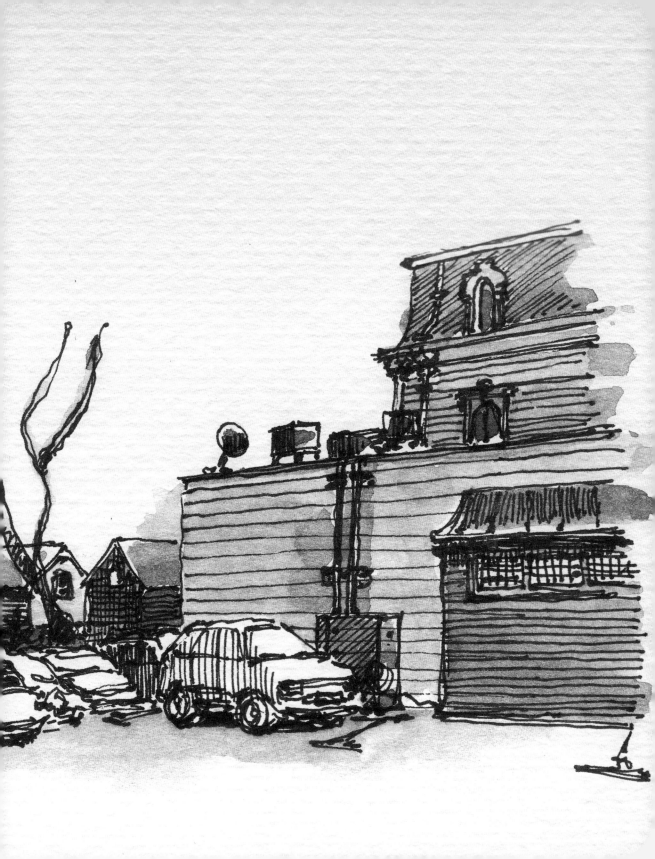

# Contents

CRAYOLA®
PIP-SQUEAKS

PAPERMATE®
ERASER STICK

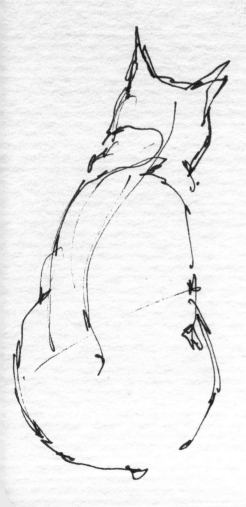

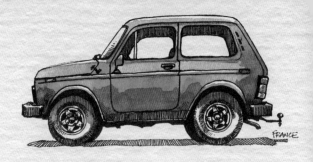

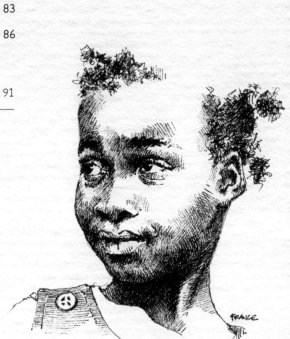

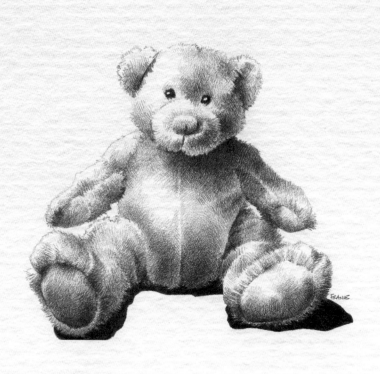

# Introduction

Think about what got you fired up as a kid when you played. Was it building forts, organizing tea time, making snow igloos, or fishing? Personally, I cannot dissociate my childhood memories from LEGO bricks. Most of my time that wasn't dedicated to school was spent playing with them. I had two giant boxes of pieces, plus a bunch of flat LEGO building plates. I loved building houses. I would spend entire afternoons on an optimal home floor plan, and because I had so many pieces, I could really go to town: patios, four bedrooms, big tables, big beds, two-car garages, and wide hallways. I would work on a house for hours on end, looking forward to then putting the little LEGO guys in, choosing the right cars for them, and, finally, *playing* with the house I had just built.

Each time, I would be so excited about the prospect of having a new house to play with, and inevitably, once it was built, my interest would fade and die almost instantly. Within a day, I would dismantle the building I had just made and start a new one from scratch.

Only later did I finally understand that I got my kicks not out of playing with each house, but out of building them. It was the process of building that had me all fired up. Once that stage was over, so was the fun. Even though my goal starting every house was to see the finished product and use it as the backdrop to my little LEGO stories, the biggest stimulus was building. The search for the right piece to fit in a little corner, which would then have me run into other pieces that I would use, the choices I would make along the way, all this *was* playing LEGO.

Drawing is very much like building a LEGO house. There may or may not be much planning involved, but while your goal is to produce a drawing, you will find that the real joy of drawing lies in the drawing process itself: the subject, paper, paper orientation, pen, pencil, size, speed, pressure, color, strokes, angles, and mess ups.

This book is about celebrating the little journey we take every time we sketch. It offers some "how-tos," what to draw with, what to draw on, and creativity prompts—in other words, what will get you to simply draw.

# PRELIMINARIES

Have you ever wanted to simply draw but didn't because you did not know what to start with? Is your lack of training a source of inhibition? Have you ever felt a longing for artistic creativity but shunned drawing because you saw it as a skill that couldn't enable you to make a living? Have you ever felt eager to document the world around you but always felt poorly qualified to do so? Have you ever needed a creative kick-start but never knew where to turn? Have you ever felt discouraged by your own incapacity to lay something right on paper?

I have.

Oh, and have you ever thought you had to be formally trained in order to draw? Because the truth is, you don't. But I am willing to bet it helps. I for one have not learned to draw and yet I draw as often as motherhood and a full-time job allow.

## ON BEING UNTAUGHT

I teach French and every year I explain the difference between "language learning" and "language acquisition" to my freshman students. In a nutshell, we *acquire* our mother tongue but *learn* a foreign one. When you acquire a language, you figure it out on your own. You figure out that the seemingly sharp stainless steel object that you see your parents slicing bread with is what they call a *knife*. That's because during the pre- and postverbal toddler years, you have heard them say that you are not to touch the knife. And that was the thing they are using to slice the bread. Better yet, you figure out that when

there are two or more of those on the table, they say *knives*. You are not given a quiz on it to assess if you got it. No teacher stood in front of you to make you repeat the words *knife* and *knives* and write them in your vocabulary notes. There is no homework. It's just you, experiencing the language firsthand, both as a witness (listener) and a performer (speaker and doer). The language you acquire as a child is not something you study; it is something you do. Your own curiosity, which is driven by the need to understand and communicate, is the fertile soil where your language grows.

The same goes for drawing. The beauty about not having been taught drawing is that you are in a position of the acquirer: the process of figuring it out might take a while, and you will most likely continue to figure stuff out as you go, but that process is yours. There are no shortcuts and no tricks, just the plain practice of drawing, screwing up, and drawing some more. Not unlike the infant who has listened to thousands of hours of language before uttering their first word, I observed, page after page, drawings of the greats: Michelangelo, Van Gogh, and Mœbius. My parents' art books were probably the earliest source of inspiration I had while growing up. Of course, like every kid out there, I drew a lot. But I also looked at a lot of drawings and read an obscene number of French comics by Enki Bilal, Marcel Gotlib, Caza, and Jean "Mœbius" Giraud. I was lucky to be brought up in an environment where amazing books were at arm's reach, right there in the living room. Art seemed to matter.

My last art class dates back to middle school, when our language arts teacher had us draw our favorite album covers once every other week. I remember doing a pathetic rendering of the steel guitar on the cover of *Brothers in Arms* by Dire Straits, thinking I had executed a masterpiece. I was twelve years old and I thought I would make a career out of drawing, not knowing this was the last year art was offered in my curriculum. Through the years, as I kept drawing on my own, I had to figure out why I couldn't make something look right on paper. I didn't know about the rules of perspective, I didn't know about crosshatching, and I didn't know about proportions. But I kept drawing. And it looked bad. I even went through a long spell that lasted several years in my twenties, during which I drew less, partly because I had grown frustrated with my own incapacity to translate what I wanted to draw into an image on paper. I had grandiose ideas for potential drawings, but none of them saw the light of day. I often felt stagnant. I even went so far as to believe that my day job (teaching) was what mattered most, all the while being cognizant of the fact that I was always happiest when I drew. In hindsight, it is obvious that my drawings were result oriented. I wanted to render a specific image I had in

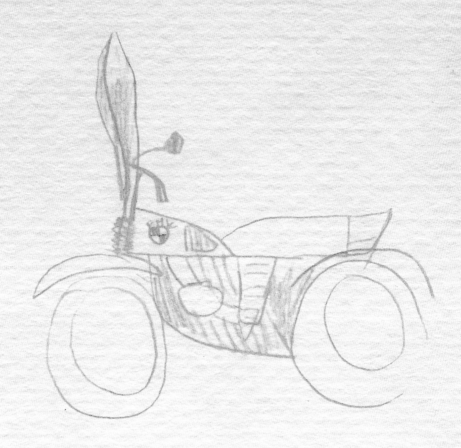

A drawing of my dad's motorcycle I did as a kid.

my head. When I failed to attain it, the frustration would freeze me for days or weeks on end. What I didn't know yet, which I learned years later, was that I was failing to focus on the drawing part of drawing. I turned each drawing into a big deal: the mood and the music had to be right, and whatever I drew (like the countless BIC pen portraits of Mick Jagger and Keith Richards I did in my high school and college years) had to turn out okay. I pressured myself into executing drawings that would consume entire afternoons and evenings, only because they had to "look like" the person I was trying to draw. I had not yet learned that the process of drawing was what brought me real fulfillment. I was removing myself entirely from the drawing process and focusing only on my capacity to create hyperrealistic portraits. I venerated the works of Chuck Close and Richard Estes (and still do) but was unfortunately missing the point of what I was trying to emulate. Then I met Raheli.

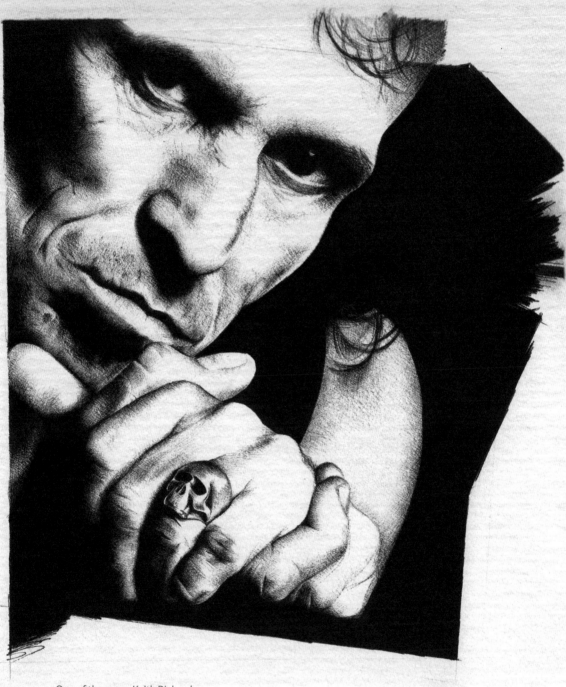

One of the many Keith Richards
portraits I sketched in college.
*Bic pen on Bristol paper.*

—EDM #85—
Store fronts

MONTCLAIR, NJ
9·24·06

It was while walking down the street one evening after a graphic design class we were both taking at the School of Visual Arts that Raheli told me, "you should check out this guy's work. He's all about drawing everything around him, like the contents of his bag." She had just introduced me to Danny Gregory, and that was nothing short of a watershed moment for me. It was then that I realized I had been missing the greatest source of inspiration for my drawings: everyday life. It was then that I went back to drawing on a daily basis.

I went home that night and drew the contents of my purse. It was a complete bust. But the difference between then and before is that I did it again the next day, and the day after that. I kept seeing things I wanted to draw around me. And the more I drew, the less of a big deal drawing became. I no longer needed to be in the right mood, with the perfect lighting, or in the right place. I drew everywhere. In the weeks that followed, I took my bike, rode for long stretches between Bloomfield and Newark, New Jersey, sat on the sidewalk, and drew. I drew every time I had a chance to sit. Drawing was no longer sacred. It was simply what I did.

I still wasn't a trained artist. I made miserable renderings of houses because I didn't understand perspective. But failed drawings didn't deter me. I felt frustrated and inadequate but I kept sketching, however painstakingly. I was

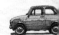

slow (still am, for the most part), but there just weren't enough pages in my sketchbooks to document the world around me. And when I was stuck on a train, I would have with me pictures of people's faces torn from magazines so I could practice drawing those faces.

After all these years of drawing, drawing had become about *drawing*, not just the drawings. As Danny Gregory himself once wrote, "That's why it's called a drawing, not a drawn."

## WHY DRAW?

Whether you are drawing a box of matches or a twenty-story building, you start by perceiving it. It is no coincidence that the word *perceive* itself takes its roots from the Latin verb *percipere*, which means to seize, to understand. When you draw, you gain an awareness of what's in front of you as you are visually grasping it.

Most of us have acquired, with time, the capacity to "tune out" the things around us. This faculty to conveniently ignore the things that don't "matter" allows us to live without being constantly bombarded with visual stimuli. We need to be able to drive or walk without being distracted by the slightest object

in our field of vision. Imagine stopping to contemplate everything on your way to work: a parking meter, the door of a building, the shape of a parked car, the leaves on the trees, the fire hydrants . . . you would never reach your destination! This is why, as adults, we have trained ourselves to disregard the landscape around us in order to keep a certain focus, that is, where we are going, how we are going to answer questions during an upcoming interview, how not to trip in those brand new heels so as to avoid public embarrassment. We only seem to truly notice things if they bring us some kind of discomfort, for example, how dirty this seat is.

I insist on saying *adults* because this capacity to ignore in order to focus can also be regarded as the ability to stop wondering. A four-year-old child marvels at everything, including the potato ricer, because they haven't yet had to rank the things that matter versus those that don't, as

adults do. That's why everything matters to a four year-old. My daughter walks by my side and notices the cracks in the cement sidewalk: "It looks like a hand!"

Over the years, our familiar surroundings have become invisible. We don't have the time to notice objects beyond their usefulness to us, like a coffee machine or a mug. Getting out a pen and paper to draw what is familiar around us is like shining a big spotlight on what we had grown to ignore. It turns the invisible into the new and, dare I say, beautiful.

The act of drawing brings everything back into focus. I personally find true joy in tuning all the little things back in. All the things that I have "visually denied" are rendered important by the mere action of looking at them with the intention to draw them. The joy of drawing is the ability to reconnect with the

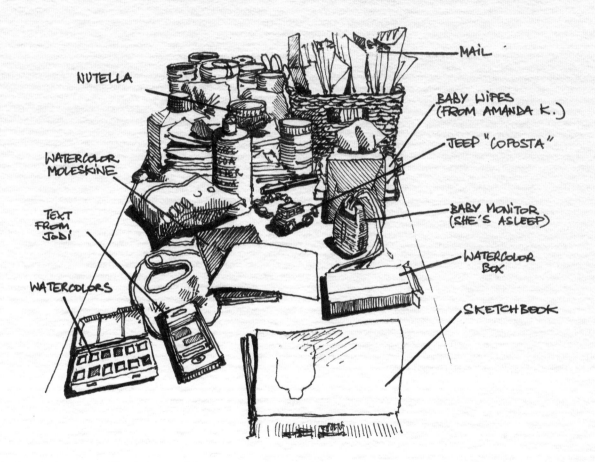

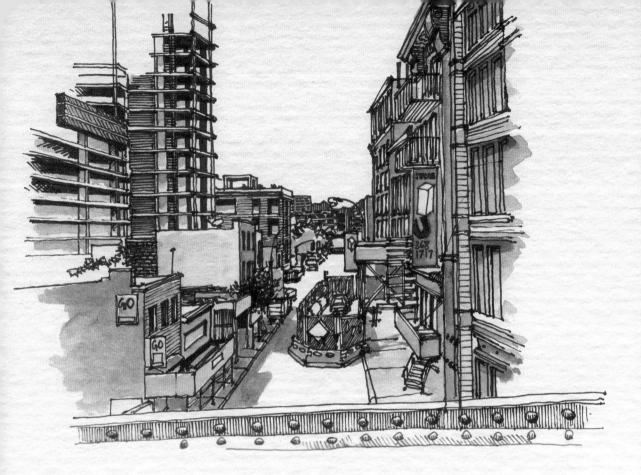

*29th street in NYC.*
*H pencil, Pigma Micron 05,*
*and watercolor in my*
*sketchbook.*

sense of wonder we all once had. Far be it from me to idealize childhood, as I wouldn't want to relive a day of it, but most children draw, and most adults don't. Yet some of us adults do feel the need to translate what we see on paper, *because we see it.* Drawing is, first and foremost, seeing.

In the age of instant sharing of pictures, why is there a need to draw? I can take a picture of my lunch and have it up on Instagram before I take the first bite. Why do some of us draw our lunch instead? What does drawing bring that photography doesn't?

First, it doesn't matter if you are extremely fast or slow: to draw something, you have to sit there. I am slow; for me to absorb a scene and put it on paper is a meticulous process. I can easily spend a couple of hours on a drawing if I have no time constraints. When I draw, I gradually sink into the moment, and the scene I draw gradually sinks into my vision. The more I observe, the more I see,

and the more I want to draw. And perhaps that is where the first big distinction between snapping a picture, however beautiful, and drawing lies: the control you have with your pen. When you draw, you constantly choose what you are including and what you are leaving out. Drawing is a series of choices that we make—"How am I going to deal with this tree? What if I ignored this car; would it throw everything off balance? Do I draw the pattern on her shirt?" All these choices amount to what makes the drawing. There is nothing instant about it. As you draw, you gradually take ownership: you alone are making decisions along the way, whether you do or don't finish it.

The process that you go through, be it for ten minutes or three hours, is the drawing. Like a visually impaired person has to feel someone's face with their hands to tell their features, I sit and gradually take in the details of a place or a person through the pen. While taking pictures with an SLR or with my smartphone is great fun, I feel involved on a much deeper level through the act of drawing. I sometimes walk through or past places I have drawn, and I am so well acquainted with them that I have the uncanny feeling of having lived there.

So, do we draw to keep some kind of record? I think I do. People keep travel sketchbooks and record what they see. If you flip through your own sketchbook from years prior, you will remember everything about the moment you drew something: the challenges you faced drawing it, the temperature outside, where you were sitting, even who came over to talk to you. Keeping a sketchbook is also the recording of the evolutions of your own drawings. Flipping through the pages of Moleskine sketchbooks I kept six years ago makes me realize that a lot has changed, not just in how I draw, but in what I choose to draw. It is not unlike keeping a diary: it is evidence of growth. My drawings were elaborate and time-consuming before I had a baby. After the birth of my daughter, I had to adapt to my new lifestyle. My drawings went from being meticulous and time-consuming to being less elaborate. In the sketchbooks I kept in the months that followed my daughter's birth, I can see the gradual shift from my

*Fiat 850. H pencil, Pigma Micron 08, and watercolor in a watercolor Moleskine.*

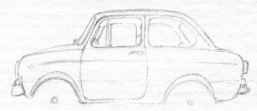

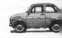

four-hour pencil portraits to quicker, sometimes fifteen-minute accounts. Sketchbooks are logbooks: what we draw and how we draw in them, when looked at in hindsight, form a bigger picture.

Though I have been fortunate to draw in the company of artists like Amanda Kavanagh, Liz Steel, Stephen Gardner, Lapin, and Paul Heaston, most of my sketchbook pages remind me of how delightfully solitary drawing is. It is a time of intense observation of the outside world as well as introspection. There are times when drawing nears meditation. Just as my best friend Micheline meditates while jogging over an hour a day, I find myself in a similar state of mind while drawing. It is a time "in which many thoughts have time to take root and unfold themselves", as Thoreau wrote in *Walden*. It is a time to reflect upon and shed worries at the same time. Danny Gregory called it "clearing the crap," and I can't think of a better way to put it. This is a conversation Micheline and I have often had. She jogs, I draw, but we both clear the crap.

## "YOU'RE SO TALENTED"

Talent—this gift God bestowed upon a lucky few: people around me, my colleagues, some friends, have hinted at the fact that this drawing ability I have is pure talent. It is a common belief that those of us who draw have a gift.

I strongly believe that putting drawing down to a gift is a stance that postulates: I can't do this while you do it so well, so why should I try? I don't have the "gift," Dismissing drawing well as a gift is a cop-out. While I don't deny that history has had several geniuses in the realm of music and art, I think most of us who can draw a portrait or a tree do so because behind each drawing, there have been hours of prior drawings. I sucked before I could draw anything half decently, and unfortunately for me, sucking at drawing is not over. I still fail. I still draw painstakingly.

It is hard to explain to friends who have asked me to draw their dog or their grandchildren that those portraits will take me hours, that there will be nothing easy and relaxed about them. I will struggle. I might be hesitant and disrupt

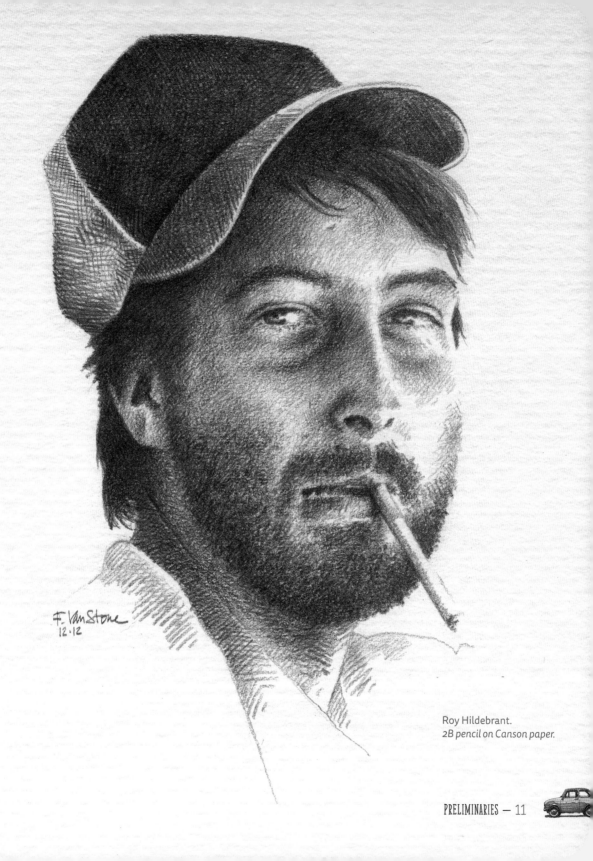

Roy Hildebrant.
*2B pencil on Canson paper.*

my own flow. I might even have to start over and hate everything about drawing for a little while.

Artistic talent is a shorthand for countless hours, months, and years spent drawing. When I was in high school and my girlfriends were out shopping or going out with guys, I was the kid who spent hours at her desk drawing. I drew not out of feeling socially inept, but because I loved it, despite the frustration caused by failed drawings and my own limitations. The reason why I can draw a decent-looking car today without a model is because I have drawn dozens of them before. And the one I draw today is not necessarily one I will be happy about. The few minutes or the few hours I spend on a drawing are the continuation of the thousand of hours I have dedicated to drawing in the past few years. These current drawings are, also, a passage in the hundreds of hours I will most likely continue to pour into scratching away on the surface of paper with a pen.

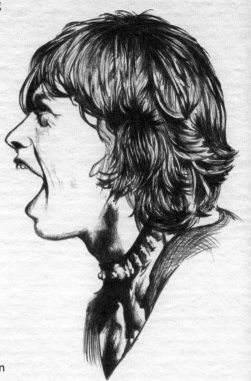

If talent exists, my definition of it is this: it is the capacity to spend innumerable hours doing something and to believe that somehow it matters. And perhaps if God had a hand in it, it was in planting that tenacity in some of us.

This book offers no magic formulas and no shortcuts. There is no escaping the fact that a drawing is about drawing. But the laborious process of growing as an artist does not necessarily equate to tedious assignments. This is where our everyday life comes in. When you get into the habit of drawing, you experience the joy of observation and contemplation, not just watching but *seeing*. While everyone on the train has their head lowered into a smartphone, a laptop, or a tablet, you have yours lifted and you draw. You perceive. You are aware. You don't tune the moment out; you throw yourself in. Your commute on public transportation or your wait time at the motor vehicle agency is not a moment you have to kill—it is a moment you celebrate.

Let us celebrate the everyday and lay it down on paper, shall we?

Doodling in high school.
*Bic pen on Bristol paper.*

• 5·20·13  D210 •

## CHAPTER 2
# SUPPLIES

I draw with certain things out of affinity but mostly out of ignorance.
I don't know much about various papers, pens, pencils, or watercolors. For
the most part, what I use today is what I have stumbled upon, tried, and
liked, until I liked something even more. I found my first Pigma Micron pen in
a friend's backyard and drew with it. It was a little old and was losing opacity.
I immediately loved it and I have yet to find something better for my everyday
doodling. The Japanese definitely know how to make a pen.

Expensive supplies don't guarantee better drawings, and it certainly
won't make you a better artist. However, it would be disingenuous of me to
say that the price of your supplies doesn't matter at all. I get a real feeling
of excitement when I open a new sketchbook for the first time and a bit of
a sense of awe when that sketchbook is a $25.00 Stillman & Birn. But I am
also convinced that using a high-quality paper has not helped me improve
my drawing. Just like learning to play guitar on an expensive Fender will not
elevate you to the skill of Jimi Hendrix, purchasing expensive sketchbooks will
not do much for the improvement of your drawing chops. But they are nice.

Unfortunately, I don't have any art stores in a twenty-five-mile radius of where
I live, so I make do with the chain crafts store in town. This is where I buy my
$5.00 Pro-Art sketchbooks. The majority of the drawings in this book were
done in my trusty cheap sketchbooks.

I am not sure whether being more knowledgeable about supplies would
make me want to keep a variety with me at all times. I guess my own lack of
knowledge means I am keeping my supplies limited, which is a way of staying

ambulatory. Carrying more than a couple of sketchbooks can be cumbersome, especially when they are with you at all times. The ones I carry happen to be the only ones I own: my cheap Pro-Art and my Stillman & Birn. I also have to be able to carry pens and pencils in one relatively small pencil case. Portability is an important factor if you want to make sketching a habit. It might force you to be selective in your supplies, which is a good thing if you tend to be indecisive. Sometimes, letting the pen decide what kind of drawing you are getting into is liberating. It is all part of relinquishing control over the process of drawing. This is a topic I talk about in chapter 4, Drawing when Time and Resources Are Limited.

## TOOLS I USE FOR DRAWING

I deliberately titled these next few sections Tools I Use for Drawing, Tools I Use for Adding Color, and so on instead of "Tools *to* Use for Drawing," "Tools *to* Use for Adding Color," and so on. These sections are about what I use, not necessarily what you ought to use. You might try these and like them or you may decide they are not the best for you. The most improtant thing is to find what works for you and what you feel comfortable using.

### Pens

I used to draw exclusively with Pilot Precise V5 and V7 black pens. If you want to see amazing ballpoint pen drawings, check out Andrea Joseph's art at andreajoseph24.blogspot.com. Her drawings may inspire you to play with ballpoint pens.

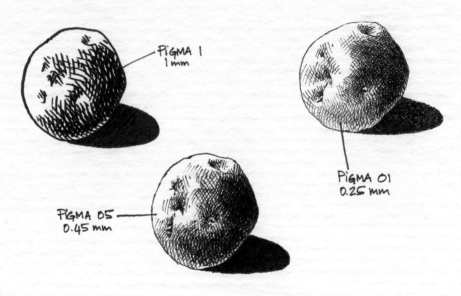

PiGMA 1
1 mm

PiGMA 01
0.25 mm

PiGMA 05
0.45 mm

While I still love the flow and thickness of the Pilots (and still swear by them for writing), the quality of the ink does not match that of the Pigma Microns. And once I got used to the darks I could achieve with Pigma Microns, I stopped using ballpoints. You can add watercolor on top of Pigma strokes, and they will not bleed.

My favorite Pigma is the Micron 05, because it is not too thick or too thin. This is the one I am most likely to grab first. The Pigma Micron is ideal for more intricate details and thinner lines. The Micron 01 is what I use for shadows. On the lower left is an example of a potato that I drew with all three Pigmas to give you an idea of how much a drawing can be affected by the thickness of the pen. Depending on how you hold it (see chapter 3, Basic Techniques), the Pigma can yield different results. Perhaps I love my Pigma Microns because I have not tried anything else since discovering them. If time and resources allow you to experiment and carry around more material, go ahead and "test draw."

I sometimes whip out my fountain pen, which happens to be the one I used in high school. It is still in great shape, and the ink flow is still as reliable as it was two decades ago. The Waterman ink, however, washes off with any hint of water, so my fountain pen and watercolors don't mix.

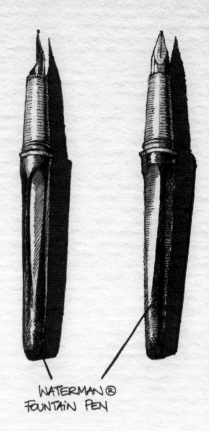

WATERMAN® FOUNTAIN PEN

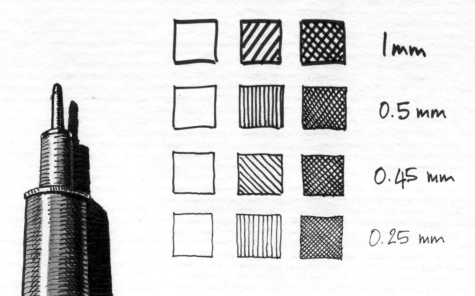

1 mm

0.5 mm

0.45 mm

0.25 mm

## Pencils

I have a preference for 2B pencils, regardless of the brand, and seldom stray from that. Why 2B? I think it achieves the best darks if I put enough pressure on it but can also be handled very lightly and work almost like an HB pencil.

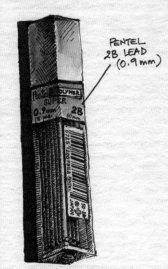

PENTEL
2B LEAD
(0.9 mm)

I love lead holders, because I never have to carry a pencil sharpener with me or worry about the tip getting dull. My favorite is a Pentel Twist-Erase 0.9 mm. Its lead is thicker than what is usually found in stores (0.5 and 0.7 mm are the mainstream thicknesses out there), so I had to order it online.

I also have a penchant for much thicker leads, like the Cretacolor 2B (#26182) graphite in a KOH-I-NOOR Versatil lead holder (#5347). Why lean toward thicker leads? When the tip becomes chiseled, it covers a lot more ground. If you turn it slightly, it is sharp and can be used to crosshatch.

While I swear by 2B pencils, I always keep an H pencil around. If it were 2H or 3H, it would probably be even better. Next time I go to the art store, I must remember! These harder pencils allow for lighter strokes, which are perfect for a quick preparation drawing, if you have time for it. I recently got a chance to sketch alongside the amazing Paul Heaston (paulheaston.com), and found out he uses a 6H pencil for his preliminary drawings. Whether you intend to draw over it in darker pencil or pen, the H-range pencils are the best ghost graphite, that is, easy to conceal.

Though I bought it years ago, I have finally started using my General's charcoal white pencil. It is a great instrument when it comes to highlights on a darker background. As far as I am concerned, the duller the charcoal white is, the better: it makes for blurrier highlights, whether used with a pen or a pencil.

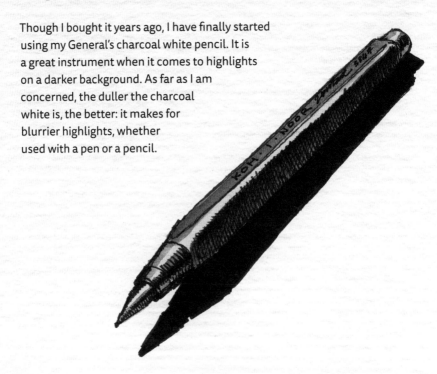

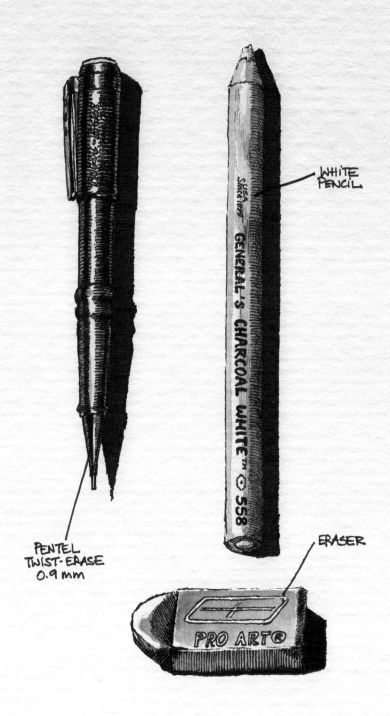

WHITE
PENCIL

PENTEL
TWIST-ERASE
0.9 mm

ERASER

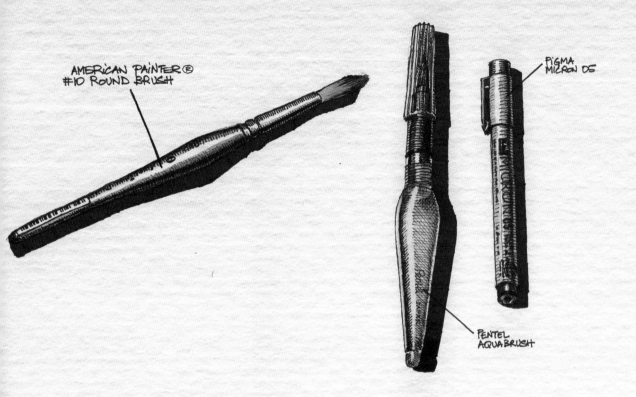

AMERICAN PAINTER®
#10 ROUND BRUSH

PIGMA
MICRON 05

PENTEL
AQUA BRUSH

## TOOLS I USE FOR ADDING COLOR

### Brushes

I never added watercolor on the go until I bought a Pentel Aquash brush. It
is a portable brush, the body of which contains enough water to last for days.
One day I was sketching next to the talented Amanda Kavanagh; I'd ordered
my Pentel Aquash online but it had not arrived yet, but Amanda was using one.
She told me "This thing will change your life." It was barely an overstatement.
Being able to add watercolor on the go, when the only support you have is your
lap, is of immeasurable value. I ended up getting two Pentel Aquash brushes:
a large and a medium. I find myself leaning more toward the medium one
because my drawings are sometimes so small, the details necessitate use of
a smaller brush.

The only other brush I own is the one I keep at home: the American Painter
brand from Loew-Cornell. I usually buy what the chain craft store carries.

## Watercolors

It is thanks to Liz Steel (lizsteel.com) that I got acquainted with Winsor & Newton watercolors. Had it not been for her, I would still be using my four-year-old daughter's Prang washable watercolors (including the brush that goes with them) and would not know what true, deep pigment means. The Winsor & Newton Cotman Deluxe Sketchers' Pocket Box set has introduced me to a much higher level of pigmentation. The pigment is so rich that very little color is actually needed to create results. There is no turning back. All the drawings in this book were colored with Winsor & Newton watercolors. The size of the Cotman Deluxe Sketcher's Pocket Box is perfect for transporting everywhere.

WINSOR & NEWTON
POCKET WATERCOLORS

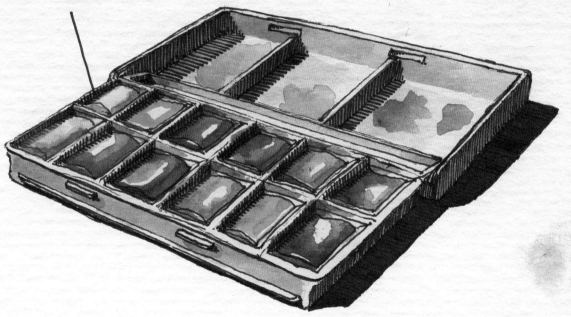

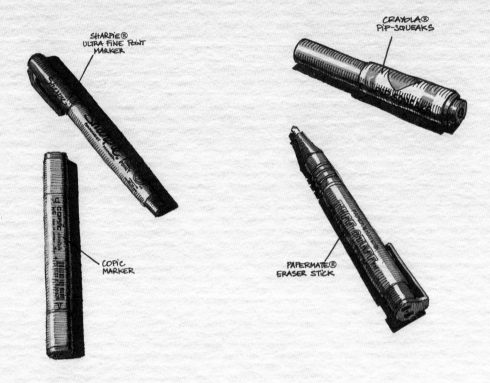

SHARPIE®
ULTRA FINE POINT
MARKER

CRAYOLA®
PIP-SQUEAKS

COPIC
MARKER

PAPERMATE®
ERASER STICK

### Color Pencils

When I use color pencils, I have a propensity to use the soft Cretacolor ones. They are sold individually. I have yet to experiment with watercolor pencils even though I have had a box in my possession for months.

### Markers

I own two Copic markers: one is warm gray and the other one slate. I rarely use markers to color anything. When I do, I borrow my daughter's Crayola Pip-Squeaks.

## TOOLS I USE FOR ERASING

Since I do the majority of my drawings in pen, I seldom get to erase. But when I work in pencil, the Paper Mate Tuff Stuff eraser is a clever little eraser. It is so thin, it allows for reaching into intricate spots on the drawing. I have been using it for years. Any other generic eraser works for me as long as it's white and plasticky.

# PAPER I USE FOR DRAWING

A pen is only great in relation to the paper you are using, especially the thickness of that paper. I find the Pigma Micron pen is the one that adjusts the best to different paper types: whether I am drawing on thick paper with tooth, watercolor paper, or plain copier paper, the pen doesn't "slide" easily on these surfaces, and that's precisely what I am after. Because I hardly ever prepare my drawings in pencil first, my strokes in pen can be a little tentative. That's why a surface with a little bit of texture and a pen that works well with it are ideal for me.

## Sketchbooks

As mentioned, I alternate between sketchbooks. I have had a couple of Moleskine sketchbooks going for years now, and I might even finish them one day. But the more I use watercolors, the more I lean toward whiter paper like the one found in my cheap Pro-Art sketchbook. It is not exceptionally thick—in fact, it is guaranteed to buckle with watercolors—but the paper has the right amount of tooth. And you can't beat $5.00 for two hundred pages. I don't have very high expectations for this paper, and somehow it feels as though my screw-ups are easily forgiven as well.

8"

5.5"

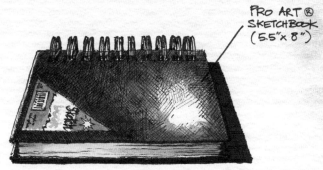

PRO ART ®
SKETCHBOOK
(5.5"x 8")

LARGE
MOLESKINE®
SKETCHBOOK
(5"x 8.25")

LARGE MOLESKINE®
SKETCHBOOK
(5"x 8")

I have also drawn in Moleskine large (5" × 8") sketchbooks for years. The extremely smooth surface is suitable for both pen and pencil. The thickness of the paper allows for drawing on both sides comfortably without worrying about anything bleeding through. Be careful not to purchase a plain Moleskine notebook when you want a sketchbook. The weight of the paper is different.

The Moleskine Japanese album is an alternative to the regular sketchbook. Its pages are one big sheet which is folded, accordion style.

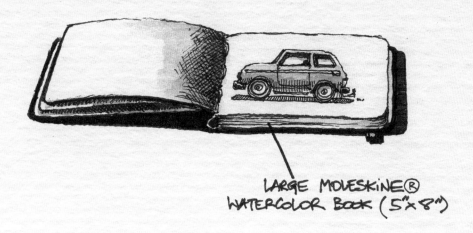

LARGE MOLESKINE®
WATERCOLOR BOOK (5"×8")

The perfect sketchbook for watercolors is the
Moleskine Watercolor Notebook. The paper is so
heavy, you will never have to worry about it buckling
with washes. The horizontal format turned it into the
perfect frame for my car drawings (see in chapter 6,
Prompts).

Only recently have I acquired a Stillman & Birn Gamma
series sketchbook with ivory paper. It also has the right amount
of roughness, and the thickness of the paper is ideal for pen,
pencil, or light watercolor. It might be the nicest sketchbook I have
ever used.

I once bought a recycled paper, ring-bound Earthbound sketchbook
on a whim, partly because I knew I owned a white charcoal pencil and
wanted to try it. The feel of the paper is perfect: it is smooth, but the
recycled particles give it just the right amount of texture. All the drawings
with an earth-tone background were done in this sketchbook.

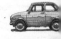

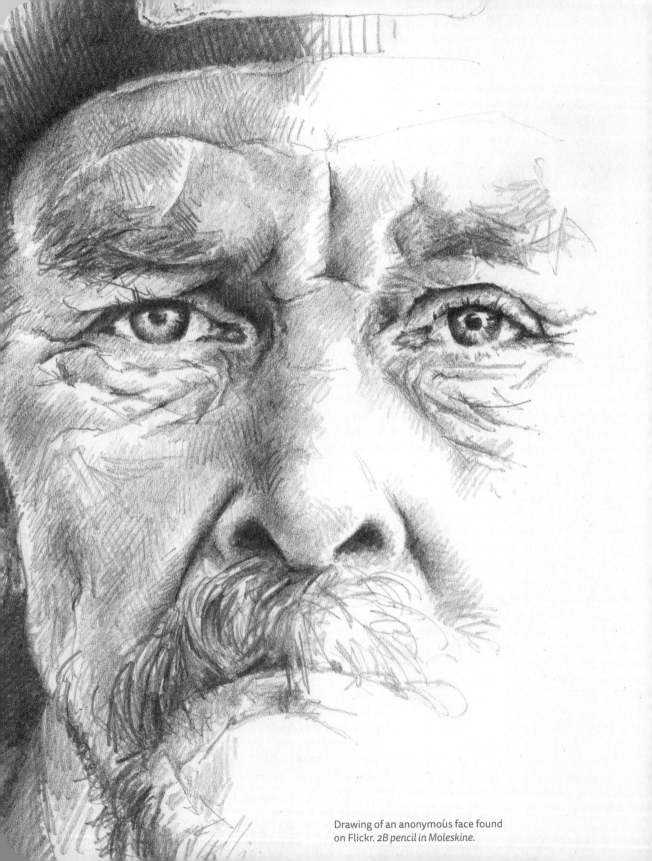

Drawing of an anonymous face found
on Flickr. *2B pencil in Moleskine.*

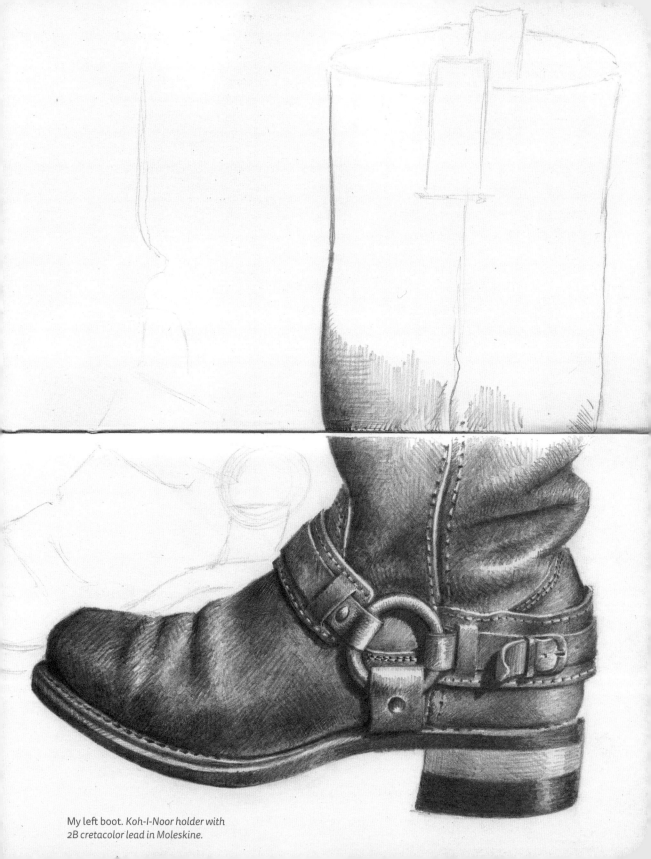

My left boot. *Koh-I-Noor holder with
2B cretacolor lead in Moleskine.*

## Loose-Leaf Paper

I have used Canson 9" × 12" for larger format commissions and other time-consuming drawings like these. The cream color is a beautiful background for pencil. The surface, not unlike the Stillman & Birn paper, is nicely textured. I have used the Canson exclusively for pencil drawings.

Bristol paper is great for Pigma Microns and pens in general, even fountain pens. Because the surface is extremely smooth and the paper so thick, you can really go dark, applying pressure, and not worry about damaging anything.

Any other paper I use is deliberately random. I never want to turn drawing into a ceremony (see chapter 1, Preliminaries); therefore anything close at hand is potentially good. This is how a lot of my drawings end up on envelopes, packages, photocopy paper, or folders. This deliberate randomness forces me to explore other surfaces and accept the challenge of size.

Drawing from a photo.
*3B pencil on Bristol paper.*

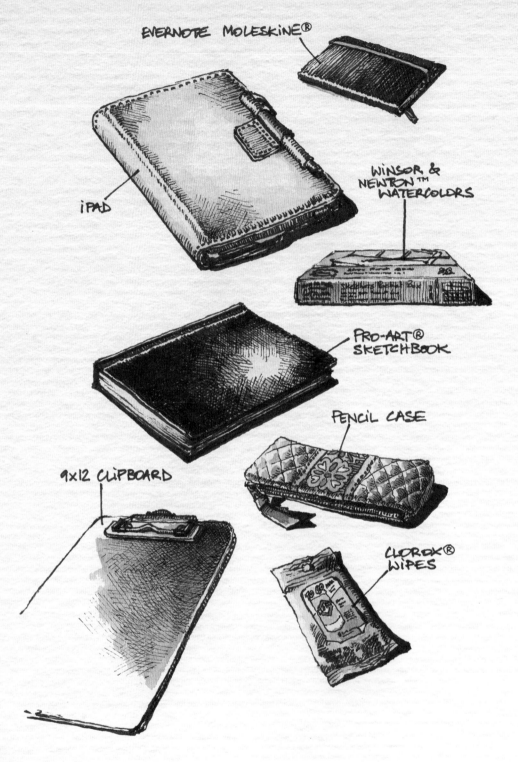

EVERNOTE MOLESKINE®

iPAD

WINSOR &
NEWTON™
WATERCOLORS

PRO-ART®
SKETCHBOOK

PENCIL CASE

9x12 CLIPBOARD

CLOROX®
WIPES

## HOW DO YOU CARRY ALL THIS?

My purse, the one I take everywhere and without which I never leave the house, is a big backpack. Because I never knows when I'm going to have a little window of time to draw, the backpack contains everything I need, or just about: my iPad, two sketchbooks, my pencil case, my watercolors, and a clipboard.

## OTHER TOOLS I USE

After I spent a day sketching in Brooklyn, sitting on an upside-down bucket, I decided to buy a fold-up chair. It is easy to carry on the shoulder when it has been folded and slid inside its sheath. The artist Liz Steel, with whom I have been lucky enough to sketch, uses a folding stool with telescopic legs from Sweden, called a Walkstool. Check out their products at walkstool.com. Until I can splurge and get a Walkstool myself, I have a preference for my fold-up chair or $5.00 bucket because I lean forward when I draw, with my lap as my support. I now keep the chair and bucket in the trunk of my car.

## TOOLS AND MATERIALS I DON'T USE

I do not have an affinity for paper that is too thin. I had high hopes for the Moleskine Evernote notebook I ordered online, but I find myself having to skip every other page to draw or write something that is not going to show through on the other side. The same goes for Moleskine journals, which are soft cover. That paper is too thin even to draw on in pencil.

I don't like blending tools. I have tried to blend pencil with a *tortillon* (a tightly wound piece of paper with a pointy end) before, but it obviously wasn't the right tool for graphite.

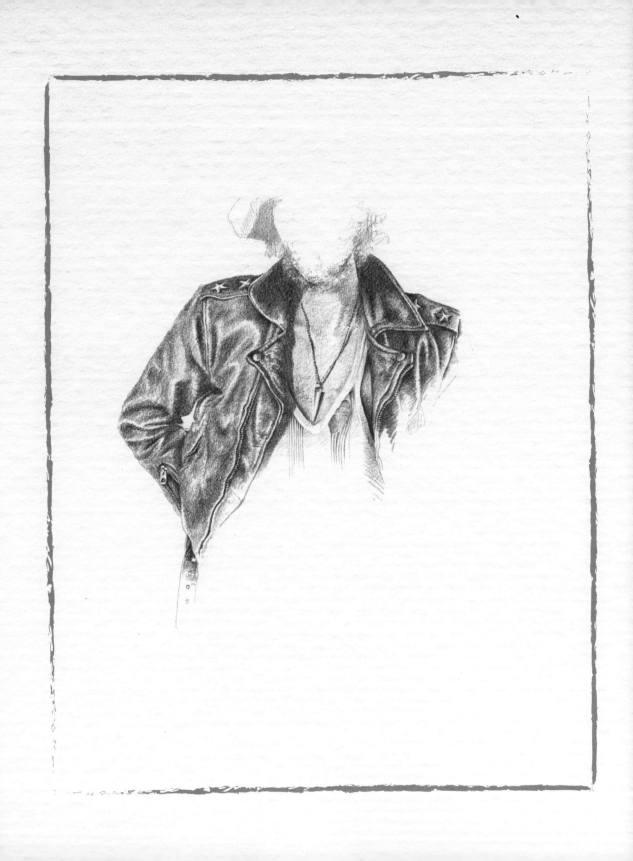

CHAPTER 3

# BASIC TECHNIQUES

I have never learned any proper techniques when it comes to drawing. There is a bit of irony in me attempting to write a chapter on techniques, knowing my last drawing lesson dates back to elementary school, when Mr. Siegwalt showed us how to shade a cylinder. I have learned everything I am about to break down here through observation, primarily of a book of Michelangelo's drawings and engravings by Dürer. How the greats rendered volume, light, shadow, the fact that they drew study after study of a body part or a drape always fascinated me. I got most of my inspiration for technique from their work. Search for them online or at your local library and study the details closely.

In this chapter, you will learn a bit about loosening up, about crosshatching, about how to get a drawing started, about pen and pencil pressure and angle, and about adding color.

## LOOSENING UP

Now that you are facing a blank page, know that it is not always easy to put the pen down to it. Sometimes we get stuck, not for lack of inspiration, but because the hand hasn't loosened up. It feels tense, we grip the pen wrong, we put too much pressure on the pen from the start. I have had countless moments like these, and after years of following the works of fellow bloggers, I have learned about the benefits of doodling to loosen up. This is as much a loosening up of the hand as it is of your mind. You unwind a line on paper as you unwind what is in your head. A perfect example of this is drawing

a continuous line taking random 90-degree turns on a page without lifting your pen off the paper or the tablet. Just let your hand go, not too fast or too slow, but at a pace that feels comfortable. These kinds of doodles are precisely about that: turning the discomfort caused by an attempted drawing into ease and comfort. They are about finding your groove.

What matters here is not to try to make this look like much, but just to get some marks on the paper. You can call a friend and doodle while on the phone. Letters, little trees, random lines or houses, and patterns are a great way to make something happen, without trying to render something that is in front of you. I would be tempted to call these "mindless" doodles, but they are anything but. They do wonders for the mind. They relax and unburden it. Their repetitive nature does not turn the mind off, but instead refocuses it in a very gentle manner.

If you use Pinterest, search for Zentangles to find inspiration for patterns. Sometimes spending a couple of days drawing patterns instead of drawing from life helps realign your focus. They are a mix of fun and zany aesthetics, and producing them prevents you from taking yourself too seriously. What they do above all, however, is make you comfortable with the pen or the pencil you want to use. By drawing silly patterns, you will not only get acquainted with your writing implement but also with its relationship with the paper. You will know what works and what doesn't. You will find the limits of your paper: how much darkness it can take before the ink bleeds through, whether it buckles under your hand, or whether the tooth it offers is too much or not enough for you. Doodles are not about performance; they are somewhere between practice and delving. You might bring back things you used to draw as a kid and that you have buried with the years: silly flowers, repetitive circles, squares, endless checkers, fish. You might find yourself reconnecting with little joys you had lost sight of. Don't brush them off as a waste of time. You will learn a lot about drawing, and about yourself, drawing with these little patterns in boxes.

There is nothing like blind contour to throw you into the process of drawing. *Blind contour* is drawing what is in front of you without taking your eyes off of it—and without looking at your paper or your hand. It can be fast and simple or more intricate, depending on how much time you want to spend on it. Because you are never looking at the paper or the tablet, you are not burdened by

Our cat Peaches drawn in a few seconds on my iPad.

"what it looks like" and therefore can focus exclusively on what you see. You simply let your hand transcribe it on paper.

It is about drawing, as opposed to accomplishing a drawing. This exercise is beneficial on several levels: From an eye-to-hand coordination point of view, it is as if, for a few minutes, you allow yourself to bypass your overanalytical left brain. You do not second-guess yourself; you do not stress about rendering. You just absorb the forms of what you draw. From a loosening-up point of view, blind contour allows you to relax physically and move your hand about the paper without worrying about the consequences. It is a great way to warm up for drawing what you want to draw. It also desacralizes the experience, that is, the act of drawing in blind contour takes away the ceremonial aspect of drawing. Because the blank page can be a source of stress, blind contour helps you jump in, head first. It also guarantees a good laugh when you look at the results.

A quick blind contour of Keith Richards in my blind contour sketchbook.

Don't underestimate the power of lightening things up when you venture into "art." Loosening up is as much mental as it is physical. I recommend having a sketchbook dedicated exclusively to these fun, spontaneous, blind contour exercises so that within a few days, you will have covered pages. This will help alleviate anxiety about not producing anything on paper. When you draw in blind contour, you are throwing yourself into the process of drawing instead of making projections about the outcome. In other words, when you draw in blind contour, you are in the *now*. The more you do it, the more this outlook will become a part of you: trust your eye, trust your hand, and trust your capacity to enjoy the process of drawing.

Lotion bottle in my blind contour sketchbook.

Blind contour of my husband's legs done on my iPad.

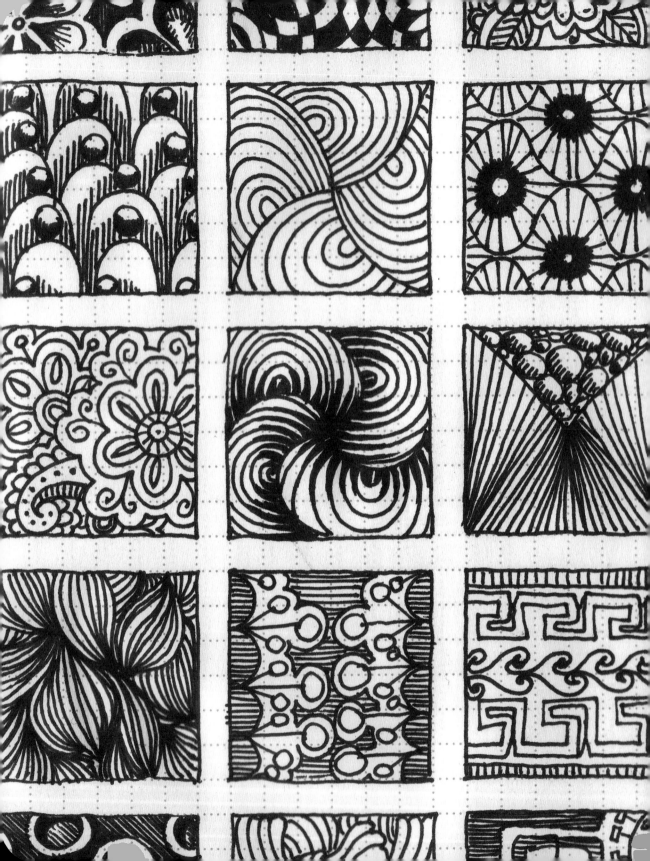

# CROSSHATCHING

Crosshatching is a way to translate light and volume. Whether I draw with
a pen or a pencil, I always revert to some sort of crosshatching to render
darker areas. Observing the works of Robert Crumb or Mœbius, I learned the
difference between straight and curved lines on a surface. I often look at high
school students' work hanging in the hallway at my school and something
I notice is that they draw a lot of straight lines, as if they had rushed through
the assignment to translate a three-dimensional subject such as a face or
a shoe. I do not know the first thing about sculpting, but I have the feeling this
is where drawing comes closest to a three-dimensional skill: know what the
shapes you are drawing are doing.

Here are two examples of circles. The top one is gradually shaded with
straight lines, while the bottom one is being crosshatched with curved lines.
Crosshatching while "feeling" the rounded shape is crucial to me. The circle
that has been filled with straight lines looks more like a disk, while the curved
crosshatched circle looks more like a sphere. Again, observing the works of
Michelangelo teaches a great deal about how to render volume.

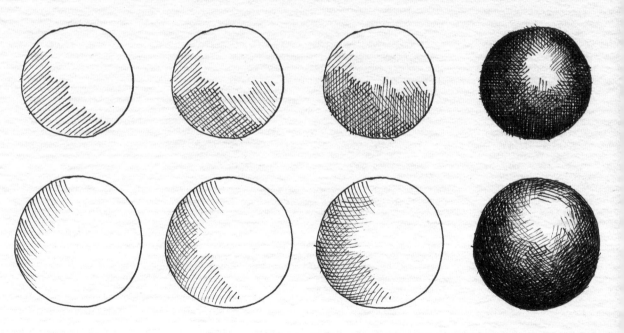

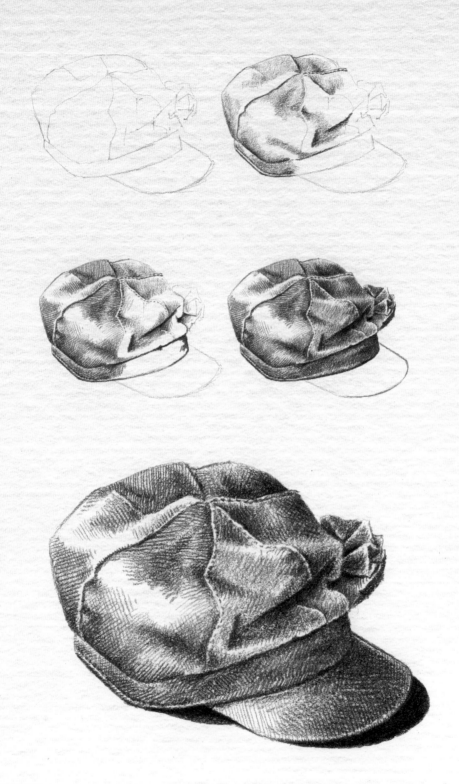

Whether you choose to sketch with a pencil or a pen, you will want to experiment with what crosshatching does to a drawing. In pencil, I find myself wanting to lay a "blended base" to any crosshatching, that is, softly running the pencil on the paper in areas that seem to be the darkest. That way, I am not afraid to crosshatch because my background is already dark. This is what the breaking down of the hat drawing shows. I am sure there is a far more conventional way to use a pencil, but I tend to treat pencils as I do pens. And since I use rather thick graphite leads (see chapter 2, Supplies), there is always a sharp edge to the lead to make crosshatching marks.

There is, however, such a thing as overdoing it when it comes to crosshatching. The avocado above exemplifies that. My avocado got smothered in darkness here. I should have left a larger lighter area.

Just as I love to use crosshatching to convey volume, I love drawings that are entirely devoid of crosshatching. Below is a remote control. I left the first version alone and crosshatched on the second one. My favorite artist in the noncrosshatching area is Michael Nobbs (www.sustainablycreative.com). I wish I could sometimes refrain from adding more to my drawings so they could look more like his.

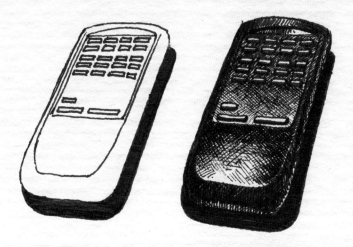

If I think I am going to add color to a drawing, I sometimes keep crosshatching to a minimum. But I cannot help wanting to convey volume with pen. Here is an example of a mix of crosshatching and color: a pig commissioned by my daughter. I added color with one of her colored pencils.

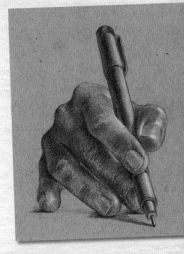

In either case, whether I add color or not, I like defining the overall shape of what I am drawing before anything else, as I have too often made a drawing "grow" on the page by losing sight of the big picture. It is easy to forget about proportions if you get too caught up in details right from the start. I have drawn many cars that could not fit on the page even though it looked, at first, as though they could.

## PRESSURE AND ANGLE

It wasn't until I started writing this book that I realized that I hold the pen differently at the beginning of a drawing than I do in the later stages of the drawing (however brief these stages may be). Because I seldom start my pen drawings with a draft version in pencil, whatever I lay down on paper first remains. In the early stage of a pen drawing, I tend to hold my Pigma Micron loosely. That allows the pen to be at a sharper angle in relation to the paper, thus letting only the side of the tip touch the paper. The marks left by a Pigma Micron at this angle are a mix of thin and faded. The strokes are a bit tentative, which to me is absolutely ideal for starting a drawing. Any mess up will not show dramatically and will most likely disappear under any amount of crosshatching. Or not. But that's the beauty of pen.

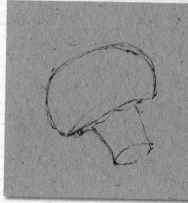

See how this drawing developed on the following page.

When I know more or less the direction in which things are going (i.e., that the object I am drawing might fit on the page after all), I tend to hold my pen differently. The first strokes of crosshatching may have been tentative, but once I have decided where to lay the darks, my grip on the Pigma Micron is more firm, and the angle of the pen is more vertical. That angle allows for more tip to come in contact with the paper, which causes the strokes to be thicker and darker. I also seem to apply more pressure to the pen when holding it this way.

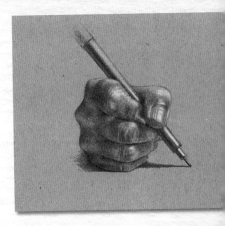

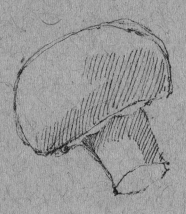

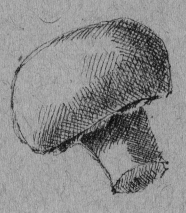

Once I have established what the shape is more or less going to be, I pause and look at the darkest areas. The way the light hits will determine where I start darkening my drawing. I start by hatching very lightly. Notice that the first hatchings are all in the same direction. I have not yet moved the paper here.

This is where the hatching becomes a little hectic. I now go in the opposite direction but keep my strokes somewhat light. I started adding more pressure under the cap of the mushroom to convey darker shades. Notice that the strokes are curves on the cap as I am trying to render a rounded shape.

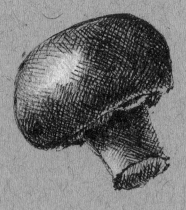

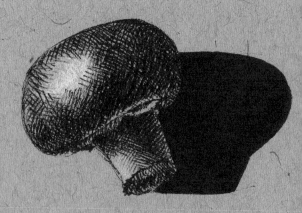

Now it seems safe to apply pressure to the Pigma to go darker. I make sure not to hatch the area that looks lighter on the mushroom so I can add a bit of white charcoal. The bit of white against the tan background makes the mushroom "pop." Notice I added more lines with the Pigma after adding the white. Also, I applied the white on the left side a bit more lightly, as that area is not exposed to as much light as the top.

I could have left it at that, but an object can float unmoored on a page unless you anchor it with some shade. I used my Pigma Graphic 1 for the broader strokes, mainly to save time. I used the Pigma Graphic to darken the mushroom cap, too, as it suddenly looked a little pale next to the expanse of black shadow.

The best way to illustrate this difference of angles and pressure is through the succession of mushroom stages (see facing page).

When I sketch with a pen, the thickness of the paper does not seem to matter half as much as when I draw with a pencil. I have a prerequisite when I tackle anything in pencil: the surface underneath the paper has to be hard, and there cannot be layers of paper between what I am drawing on and that hard surface. That is why I carry around a clipboard, which I place under each leaf of paper (loose or in a sketchbook). The faster I can achieve the darkest strokes with my pencil, the better. A stack of papers underneath renders the paper you are drawing on too soft, and instead of attaining darks, your pencil tip just digs into the paper. It makes for an aggravating experience and unfortunate results. The harder the surface, the better behaved the pencil will be. Try both: a soft surface (inside a sketchbook) and a hard surface with the same pencil. You will see how much impact each has on your drawing process.

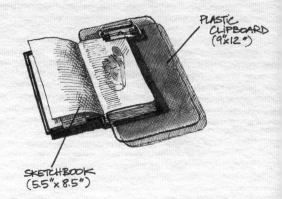

PLASTIC
CLIPBOARD
(9"x12")

SKETCHBOOK
(5.5"x 8.5")

## ADDING COLOR

When I add color, I grab my trusty Winsor & Newton set (see chapter 2, Supplies) and try my best not to mess everything up by overdoing it. One thing I found out about watercolors, especially from observing Liz Steel, is that the looser you are with them, the better; they are unmerciful if you hesitate. Let that one stroke be the one and move on. Come back in a few seconds or minutes when it has dried a bit.

FRANCE.

Whether I am adding color or putting pressure on my pencil, I have acquired (and for the most part, am still acquiring) these little techniques. They are the results of years of trial and error . . . mostly errors.

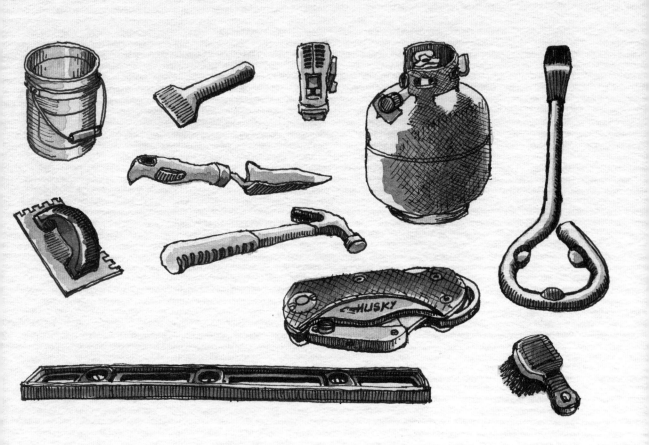

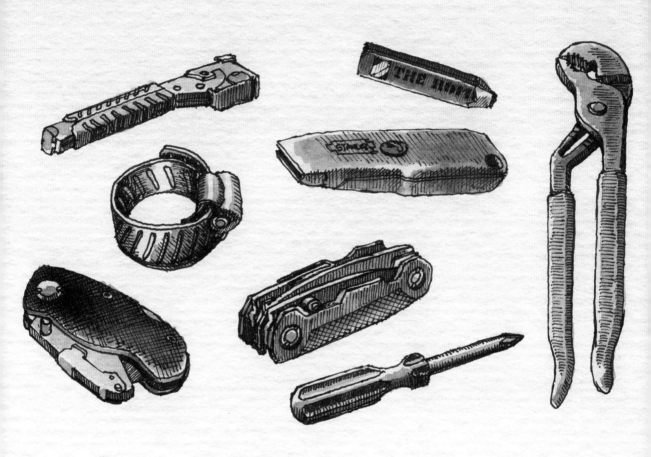

## CHAPTER 4

# DRAWING WHEN TIME AND RESOURCES ARE LIMITED

Before time became an issue in my everyday life, I had always posited that the comfortable amount of time for a drawing was an hour. Whether I was drawing a car or a portrait with a pen, an hour allowed me to get into detail and have a sense of completion. Anything less than an hour felt rushed. The reality I have had to deal with for the past four years since I became a mom has thrown a real monkey wrench into my comfortable drawing habits. At first, I had to adjust to the fact I couldn't draw on a daily basis because I was still very much caught up in my old ways. I spent hours each day nursing my newborn baby, wishing I could find a way to multitask! But once I realized that I had to rethink pretty much everything about drawing—and mind you, that didn't happen overnight—I started seeing a glimmer of light. Little by little, I figured out how to be the mom I wanted to be while working full time and continuing to fit drawing into my everyday routine.

In this chapter, I will show you how to turn a constraint (limited time) into an exercise (sketching fast) and perhaps even a habit:

☆ *What* can you sketch in a few minutes? The possibilities are endless, even if you think that what you see around you every day doesn't vary all that much.

☆ *Where* can you sketch? Can you sit or stand for a few minutes? Can you improvise a seat? If so, then you can sketch anywhere, and by that I mean

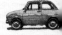

49

A quick sketch using a picture I
took of a friend's son.
*HB pencil in my sketchbook.*

that you might end up keeping a sketchbook and a pen on a shelf in the bathroom or on your bedside table.

☆ *When* will you find the time? You will see that once you let go of certain hangups that we all seem to have about drawing, finding the time will become less and less of an issue.

☆ *How* will you sketch when you only have a ridiculously small window of time? I will share some of the techniques and tools that you can always have handy.

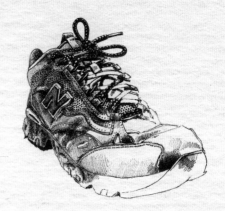

For now, let's keep it realistic. You may not learn to draw like Michelangelo, but hopefully you will be motivated to carry the idea of sketching with you always. Put another way: You will not be able to make a classic portrait of your pet in a few minutes while dinner is in the oven. You will, however, be able to focus on what intrigues you right at that moment.

## REDEFINING COMPLETION

Before time was an issue, bringing closure to a drawing was as important as drawing itself. In fact, my own satisfaction at the end of a drawing happened precisely there, at the end, at the moment when I felt I had looped a loop, when I put down my pencil, walked away to get a drink, and came back to my desk thinking "It's not perfect but it's done." In fact, so many of the drawings I did in my premotherhood years scream "closure"! But that's precisely it. Their completion was the result of a decision on my part. This luxury of choice is one I rarely have today. The most crucial of all the readjustments I had to make to juggle motherhood and drawing pertained to the idea of completion. Time constraints now determine when a drawing starts and when it ends. That is why completion has become an elastic concept. When is a drawing done anyway? Does it matter? Don't let it. What should matter over anything else is the act of drawing itself. Relinquish the concept of the finished product and draw for the sake of a few lines, however hasty, on a piece of paper—be it in a sketchbook, on the screen of your smartphone, or on a restaurant place mat.

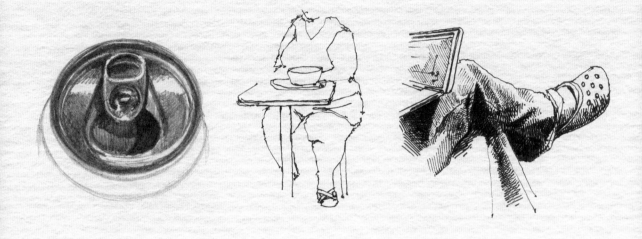

Here are a few examples of unfinished drawings. They are unfinished because some crucial parts are missing, but I have come to almost prefer my "halfway-dones" and my "quarter-of-the-way-completes" to some more detailed and sometimes overly worked sketches.

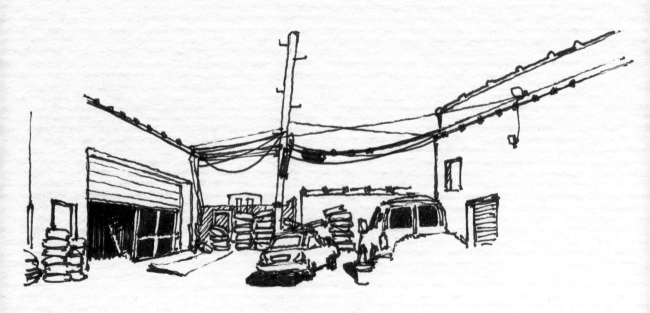

## READJUSTING YOUR EXPECTATIONS

Limited time means readjusting your expectations for what the outcome of a drawing will be. Refocus your attention on what your eyes see and how your hand translates it on paper rather than on what your finished product is supposed to look like. For the past four years, I have had to relinquish the idea of finishing and content myself with doing. Once you free yourself from the tyranny of completion, the once daunting task of starting is suddenly less intimidating. Just start—see where these few minutes take you. Walking away from what looks halfway done is not an easy task. You might want to train yourself to put down the pen after sketching half a face or certain features of a building instead of the entire thing. While the idea seems a bit counterproductive in theory, you will get accustomed to enjoying what you are drawing while you are drawing it. To be comfortable with time constraints, impose them on yourself at first by timing yourself and forcing yourself to drop everything. This will empower you to welcome time limitations when drawing.

In our everyday lives, we are constantly put in situations where we don't know how long the wait will be: at the dentist, in the doctor's waiting room, on the train, on the bus, behind the wheel, at the restaurant, in line at the supermarket checkout, or while our oil is getting changed. The biggest challenge about attempting to sketch in most of the situations listed above is not knowing how much time we will have to wait. These are perfect opportunities to send the outcome to the wind and simply draw. There is a silly quasi-adrenaline rush about drawing when we don't know how far it will go. If you can let go of the idea of finishing, if you can accept that your sketchbook will be full of half-this and one-quarter-that drawings, you will see nothing wrong with loosely tackling anything. You will not only content yourself with, but grow to love, sketching your colleague's ear and earring instead of a full profile during a meeting.

So, what can we fit in the proverbial five minutes? Not much. But, as I explained in greater detail in the chapter 3 (Basic Techniques), you can start by picking something to draw, and draw it by looking solely at it instead of the page. You will loosen your stroke and prevent your brain from deciding what that something should look like. Focus on the object of your drawing and let your hand do the drawing. These kinds of drawings can be so quick

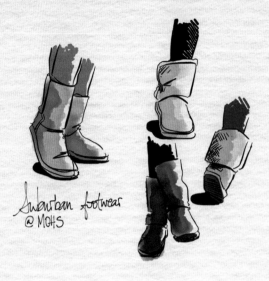

*Suburban footwear*
@ MOHS

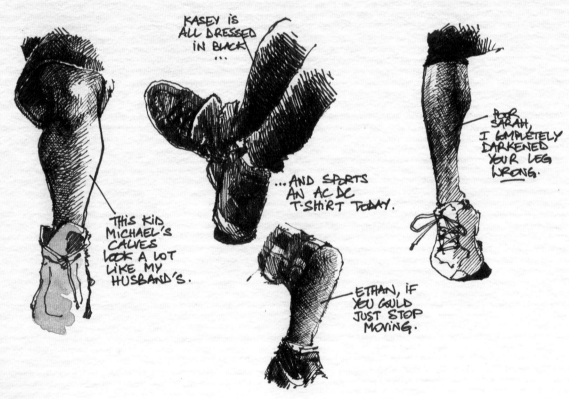

KASEY IS
ALL DRESSED
IN BLACK
...

...AND SPORTS
AN AC DC
T-SHIRT TODAY.

THIS KID
MICHAEL'S
CALVES
LOOK A LOT
LIKE MY
HUSBAND'S.

ETHAN, IF
YOU COULD
JUST STOP
MOVING.

BOB
SARAH,
I COMPLETELY
DARKENED
YOUR LEG
WRONG.

that you can knock down a handful in the space of five minutes. For example, my glass of apple juice on page 53 was done in a few seconds. This monstrous, improbable glass with its ledge floating like a hula-hoop over the rest of its body is a quick lesson for me: it shows me I somewhat kept the shapes of my octagonal glass within the glass and that my hand can produce something that resembles my object. These quick drawings might look awful from a "finished product" point of view, but they teach you to trust your hand-eye coordination. They get along a lot better than we might think without intervention from the intrusive, know-it-all, ever-readjusting brain. This is about not letting your brain drive the bus.

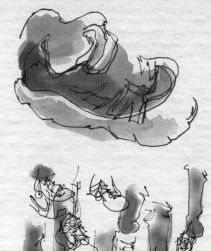

These sketches (right) were scribbled quickly, blind-contour-like, in the classroom where I was a testing proctor. Remember that these horrible drawings, however hard they are to look at, serve a purpose: they will help you loosen up and practice focusing on what you actually see rather than reinterpreting what you see. You can even add color to them afterward, with watercolor.

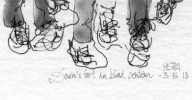

## TEN-MINUTE DRAWINGS

Once you have built that trust and loosened up a little, you will be more comfortable drawing against the clock. Here is another example of the same kind of subject (students' footwear) but treated differently. Without the blind contour to warm me up, it might not have gone well. Why are drawing shoes such a fun exercise? First, you know people are bound to move, so it's a race against the clock. Second, you see footwear in angles you are not able to see if the shoe just sits empty on the floor. Third, you don't raise too much suspicion while drawing them. I have grown to like statewide-testing week just so I can draw what students wear on their feet. Think of all the times you might be sitting somewhere in the vicinity of people—at a coffee shop, in a waiting room or on the subway—there will always be shoes and legs to sketch. During the statewide testing, students' movements didn't allow for much more than a few minutes of sketching at a time.

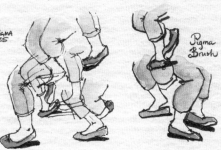

Drawing "against the clock" doesn't mean you must limit yourself to small-scale objects like footwear. The empty Department of Motor Vehicles, where I waited while my husband was getting the title for his truck, gave me a challenging exercise in perspective for ten minutes. Sometimes all you will achieve in ten minutes is a portion of what you intended to draw, such as the back of your colleague. And that's okay.

I took a writing workshop years ago. One of the most eye-opening assignments was to write for twenty minutes, uninterrupted, no matter what topic, no matter what style. Just write for twenty minutes. I found having no particular constraint other than time to be amazingly liberating. I have never written as much as when I used the twenty-minute challenge. Let's do the same with drawing. Just sit, grab paper, and draw for five, ten or fifteen minutes. If your schedule allows you to stretch that to thirty minutes or more, that's pretty fantastic. Do it. Turn off the TV and go into the kitchen or on your back porch. That is what I did for these two sketches. My family was finishing eating dinner, and I sketched for ten minutes each time. I even timed myself with a stopwatch, for fear I might get carried away. The first sketch is of a corner of the pergola as seen from our back porch, and the second is silverware drying by the kitchen sink. There is plenty of unfinished here, but that's the point. Just draw for ten minutes.

Think of when you are most likely to have a few minutes in your day. Is it at a field hockey game or when you sit in front of the bathtub on a fold-up step stool while your kids are taking their bath? Is it at the laundromat or while cooking? The *whens* and the *wheres* are endless.

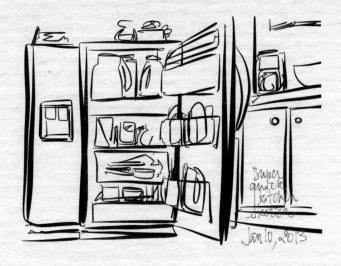

Opening the refrigerator door and sketching what's inside is a great exercise in speed because you cannot leave that door open too long. I attended a graduation ceremony recently and sketched during the speeches.

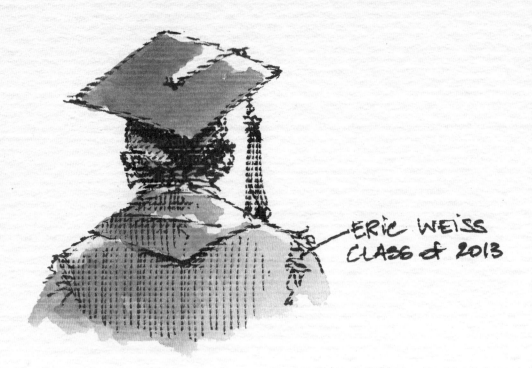

ERIC WEISS
CLASS of 2013

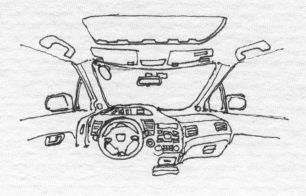

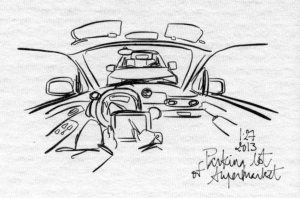

Earlier that same day, on my way to the ceremony, traffic was so bad that I could barely stay in second gear. While my car coasted gently, I did a quick sketch of my dashboard on the back of my parking permit, leaning the paper on my steering wheel. (Don't try this at home!) I did something similar, though this time on the iPad, on the parking lot of a supermarket while my husband was quickly getting some last-minute groceries.

In chapter 5, Going Digital, I will explain at length the perks of having a tablet to draw on. Tablets are the perfect companions for quick sketches. For more information on the great drawing apps out there, refer to that chapter as well.

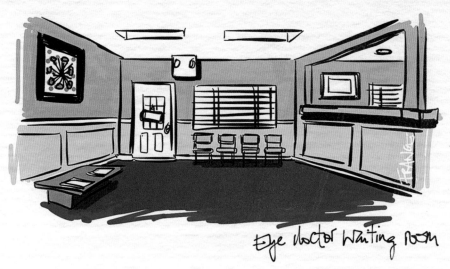

At the doctor's office there will most likely be five or ten minutes to sketch.

Eye doctor waiting room

60 — SKETCH!

# IMPROVISING YOUR SUPPORT

Ready yourself for emergency: drawing quickly means little preparation on the paper. I personally cannot draw in pencil before drawing in pen when I am rushed, because that alone would take up five to ten minutes. Quick drawings are improvised, they happen on any surface, at any moment. You will not always have a legitimate support to draw on when you only have a few minutes to spare. The ad-libbed support will be as much part of the experience as drawing itself. As I described in chapter 2, Supplies, anything goes. If the only thing you have on you is what you picked up in the mail, draw on an envelope. If it's your paycheck, a receipt, a photocopy, a textbook cover, a pamphlet, a newspaper, that's okay, too. A quick drawing on a package before mailing it is a good way to personalize something. Here is a dog (below right) I drew with a Sharpie on a parcel. The outline and crosshatching took about a half hour.

My personal favorite five-to-fifteen-minute killer is while waiting for food at a restaurant, especially if I don't pull out my sketchbook but simply draw straight on the place mat or the paper table cover. Once I accepted relinquishing the idea of completion, I realized I might as well leave the sketch itself behind. In fact, letting go of the former helps with the latter and vice versa. There is something liberating about sketching on a support that you will not keep, like your paper place mat or on the paper covering the table. It will help you desacralize the drawing and make the moment you put the pen in contact with the paper less solemn. Part of why some of us are so daunted by the mere task of starting a drawing is because we turn it into a *task*. The moment you draw on a disposable support (i.e., the place mat which will soon be dirtied), or with the intention of throwing it away, you develop a different relationship with what you draw: it won't be about the results, but about the process, for a few short minutes at least. So what do you draw at a restaurant? Anything within sight, including the restaurant itself, if you have twenty minutes to linger after paying the bill.

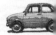

## THE UPSIDE OF DRAWING FAST

So far, drawing when time and resources are limited has meant giving up some expectations: of drawing big, of producing a detailed sketch, and even of finishing a drawing. I have spent the last few paragraphs focusing on what drawing fast is *not*. But by not drawing big, you will be drawing smaller, which means carrying around a convenient little sketchbook. You will be able to fit it in a purse or a small backpack because it will not be as cumbersome as a 9" × 12" (or larger) sketchbook. By not producing a very intricate sketch, you will force yourself to get to the essentials of what you want to lay on paper: what catches your eye and what best conveys the shape and light of what you see. By not finishing a drawing, you will let the less finished parts suggest what you actually don't need to show in detail. If my cat is lying peacefully, and I am lucky enough to catch her still, I can get a quick sketch like this one (above) in twenty minutes. But the format, just like the medium I use for this kind of drawing, is on a realistic scale: a 7" × 10" page or maybe even smaller.

Drawing in such seemingly limiting circumstances is about embracing a different approach to sketching, not bemoaning the things you cannot do.

# HOW TO DRAW WITH LIMITED TIME AND RESOURCES

With a five-minute drawing, you have to completely relinquish the idea of building your composition in any way. You lay it down on paper and think as you go. Remember that the idea behind forcing yourself to sketch so quickly is to embrace the experience of drawing rather than the finished drawing. Sometimes, my few stolen minutes are at work, like in the last few minutes of my prep before I have to rush to a classroom to teach: a stool in the art room, the elastic band that holds my sketchbook shut, and my cup of hot cider. None of these quick sketches are very elaborate. They are usually one single object, isolated from its background, alone on a page. The reality is I don't draw fast at all. What I end up covering in five or ten minutes isn't much—and probably a lot less than some artists out there whom I personally know. I can't bite off more than I can chew. Maybe in a few years, with practice, I will be able to sketch even more loosely, and so will you!

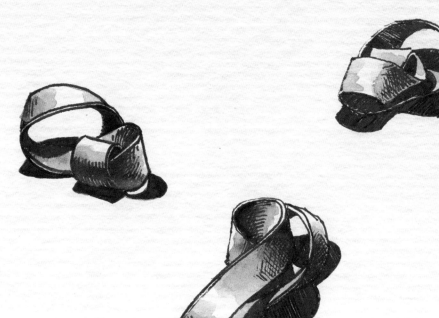

The elastic band that keeps my sketchbook shut. *Pigma Micron 05 and watercolor in sketchbook.*

You can also draw what you deal with every day, like a desk, stool, or chair. The objects that surround us are so common to us that they disappear. Sketching them is a way to bring them back into our vision and acknowledge their shape. We tend to let our brain decide what a chair looks like as we try to lay it down on paper, instead of acknowledging the actual shape of the chair we have in front of us.

Take, for instance, this ergonomic kneeling contraption that I have used for the past few months as a work chair (right). I have drawn it many times, in different circumstances, while on the phone, while taking a break from work, or to simply see *what it's going to look like today.*

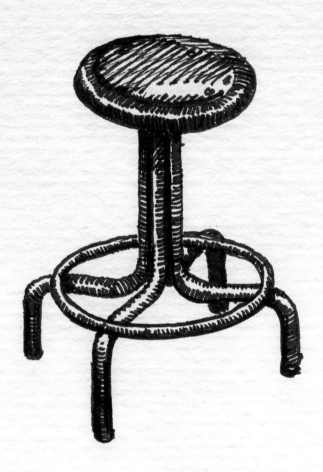

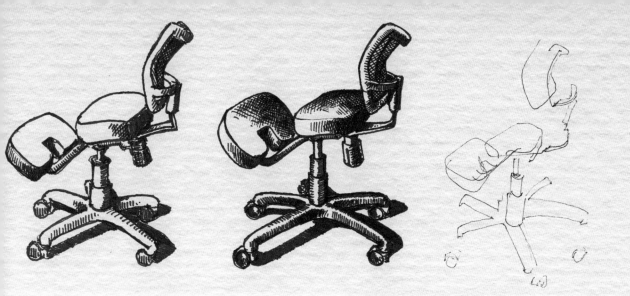

These four sketches, while very similar, were done at different times, and all four took different amounts of time: the first was done in five minutes.

The second was done in about ten minutes. Note in this case that I start to lean dangerously toward over-crosshatching everything.

The thrid sketch is a blind contour drawing of the same chair, done within one minute.

The fourth sketch took about twenty minutes.

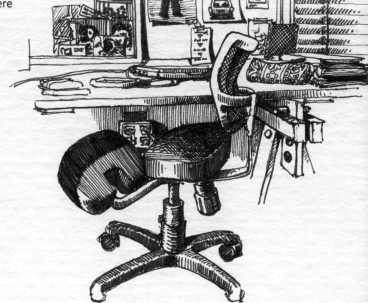

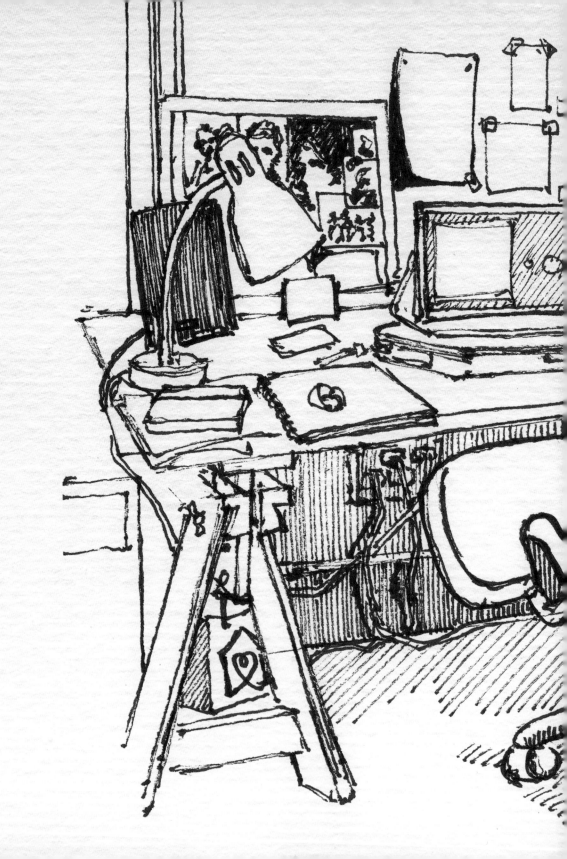

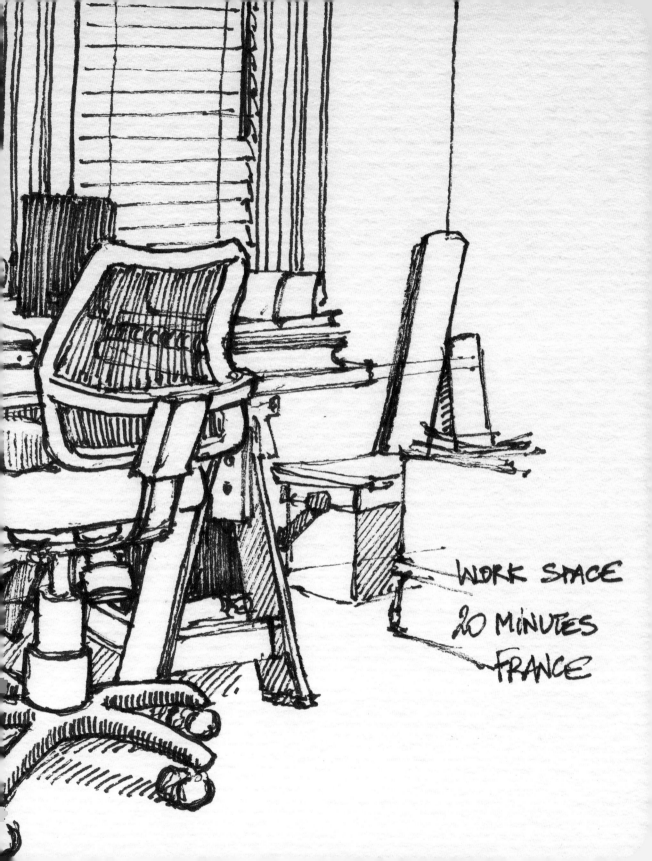

WORK SPACE
20 MINUTES
FRANCE

## ACCEPTING MISTAKES

Because they are fast, quick sketches are unapol-
ogetic. There can be a whole lot of wrong going on
in them, starting with completion and composition.
What I consider a real mess-up is a drawing that is
awkwardly located on the paper (i.e., in the margin,
unintentionally over print, or too close to the edge) or
full of perspective flaws.

These flaws are almost unavoidable when the medium
is pen. I find myself using pen almost exclusively
when my time is limited. Accomplishing anything in
pencil involves the possibility to erase, and therefore
rethink, what I am doing. Drawing in pen forces me to get in gear and prevents
me from downshifting. It's like being thrust forward, despite the mood, despite
the environment, with nothing to do but fill the little bit of time I have with
drawing. Drawing with pen, as described in chapter 2, Supplies, teaches you
to deal with the mistakes you will make along the way. If I mess up the angles
or the perspectives on a building, it will look awful, but it will show me, black
on white, what not to do. After drawing a few incorrect perspective lines in
pen, I have learned to hold my Pigma Micron in such a way that it allows me to
make very light marks on the paper. There is no fixing them if they are wrong,
but I can make the rest of the drawing darker so they do not stand out.

Dealing with mistakes doesn't mean I never get frustrated by how sketches
sometimes turn out. Case in point: sitting across from my four-year-old
daughter while she was eating chocolate ice cream yielded some pretty poor
results (above left). I was starting to draw a fork, then changed my mind and
tried to do a quick blind contour of my daughter, then sketched a lady at the
table next to us. When that didn't work out too well, I drew my daughter's cup
of ice cream. By then, even though it was less than five minutes after opening
the sketchbook, the composition was nonexistent, and all I was left with was
her dessert in the upper-left corner. I love random sketches overlapping on
a page, but these didn't turn out to be the kind I am happy about. Adding
watercolor did help a bit, but it did not salvage the unfortunate affair.

# KEEPING A SKETCHBOOK AT HAND

While improvising your support is fun, carrying something to draw on in your pocketbook or backpack at all times, as well as having paper handy around the house, is a way to keep sketching close by. I am not sure whether having a sketchbook on hand encourages the desire to draw or whether wanting to draw encourages the carrying around of a sketchbook at all times. Either way, the habit of sketching breeds more sketching, and by doing quick sketches throughout the day, you will remove the ceremonious aspect of drawing. You will accept that a paper is what it is, as opposed to how you would prefer it to be, and make do with it. It's amazing how the mere act of fetching a different piece of paper (i.e., with less tooth, smoother, thicker, etc.) or looking for the support that feels right can slow down, and sometimes discourage, the spontaneity of a drawing. That spontaneity is crucial if you want to make sketching a habit. In my own experience, the same went for playing guitar. Keeping my guitar in its case was the first hurdle that discouraged me from picking it up every day. Unknowingly, I was creating my own obstacle to avoid becoming better at playing it. Don't obstruct your own way when it comes to turning drawing into a habit. Because personal insecurities—Can I even draw? Is this good? How do I know if it's good? Should I add color? Would Robert Crumb approve?—are crippling enough, it is crucial not to add physical hurdles along the way: have paper or a tablet handy at all times. Now let's look at the ways you can make a quick sketch happen.

## TIPS

☆ On a store receipt, draw rectangles or squares on the back to serve as frames. Draw objects or pieces of objects around you within these frames. If you are cooking in the kitchen, assign a frame to a random object and draw a knife or the corner of the toaster. It won't look great, but if you notice you have the opportunity to draw while cooking, you will start keeping a little notepad or sketchbook nearby.

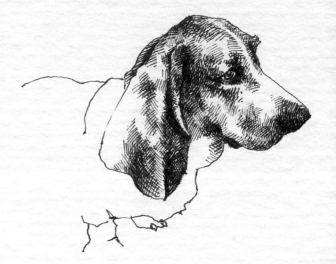

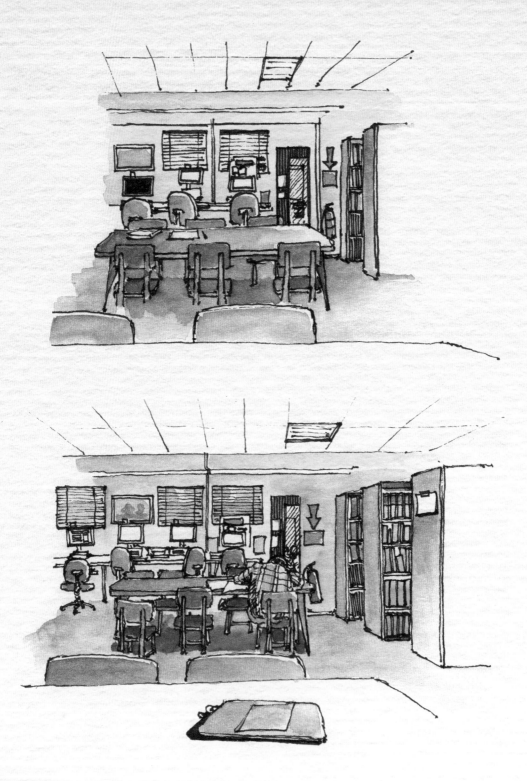

☆ Go online or dig in your computer and find a picture of something you love: a Siamese cat, a Rolls Royce, a locomotive, a World War II aircraft, an iris, a photo you saved of a friend's dog. Give yourself only a few minutes to draw it, and see how you draw it in that time frame. Don't decide that you can't draw something based on the first time you draw it. Do it again when you get a chance. And again. You will simply get better at it. It's called practice, and there are no shortcuts.

☆ Grid your surface, so that the area that you "fill" with your drawing is deliberately limited, like a thumbnail but bigger. Try gridding your page with four or five rectangular shapes and draw different details of the room you're in. The fun thing about limiting the space on which you can draw is that you might become tempted to draw close-ups, like the ones below.

☆ Focus on a familiar object, a room, or piece of architecture, and see how much you can draw in twenty minutes. Do it again in ten minutes. Now sketch the same subject but try to cut the time in half. See what you "sacrifice." Do the opposite. Draw it in five minutes, then ten, then twenty. See how comfortable you get and how you end up using that extra time. Opposite is an example of the main room of a library where I often go. The first I did in a little over five minutes; the second I did in fifteen.

Hopefully by now, you have learned to look forward to stolen sketching moments— you know, the ones that were not supposed to happen. You are no longer thinking "Nah, I'm not going to sit down and draw; I won't have the time," but rather "Hell with it—I'm drawing." You will no longer regard a time limit as a constraint, but as a fun challenge. You might even time yourself while drawing, just to see. You will draw because of time and resource limitations, not in spite of them. If you go in that direction, you will fill sketchbook after sketchbook with drawings. Pretty soon, drawing will become a habit, perhaps even an indispensable one.

CHAPTER 5

# GOING DIGITAL

Some might dismiss drawing on a tablet as being less organic and less genuine than drawing on paper. To me, while the two media are not equal, a tablet is a great tool to sketch our world.

Don't necessarily look to the tablet as a practice for paper. It can be a form of practice, to a certain extent. But the tablet is a different medium, and you have to approach it differently than you would paper. The drawing process on the digital platform differs from the analog process in many ways. Drawing on paper with a pen is like a live event: whatever happens is being recorded, and what's been done can't be undone. Drawing on a tablet offers endless revisions: you can edit it, go back, erase, and undo indefinitely. So, don't necessarily count on the tablet to be your rehearsal before you actually go into the "real deal"—that is, the paper—or you will never want to make the leap.

## THE PLUSES OF THE TABLET

☆ The power to undo. The tablet's eraser/undo function allows for unlimited do-overs. You mess up—you back up. It's very forgiving. That will help you "dive in." A mark you make with a pen on paper is permanent. What you make on a tablet is anything but. You can backtrack on every single stroke. It makes drawing more approachable if you have any inhibitions about starting. In a way, you can view drawing on the tablet like riding a bike with training wheels.

☆ Portability. You don't have to carry pens, pencils, sharpeners, brushes, paints, and sketchbooks. The tablet is *all* of those things.

☆ Versatility. The array of strokes offered in most drawing apps out there is simply astonishing. You can spend an hour just playing with strokes, colors, and opacity.

☆ Adding layers. Layers offer a fantastic way to add color or elements without compromising a drawing. Because a layer (as its name indicates) allows you to add to a drawing without affecting what has already been drawn, you don't run the risk of ruining anything in case you don't like what you've just done. Just hide or delete layers as you please. This feature helps if you are hesitant about what you are doing.

## THE MINUSES OF THE TABLET

☆ The first obvious drawback of the tablet is its cost.

☆ Without using a pricy stylus, the inability to rest your hand on the surface while you draw takes a while to get accustomed to. You must learn to position your hand differently and hold the stylus differently than you would your usual pen or pencil. It makes for an uneasy experience, because your hand has to hover instead of resting. Consequently, you will want to hold your tablet as vertically as possible, not unlike an easel. Once I figured that out, things got better. Both my right hand and wrist felt a lot less strained as a result. To some, however, not being able to rest your hand is an insurmountable obstacle to drawing comfortably.

☆ While the eraser/undo feature allows you to do something over, it does not teach you to accept a mistake and roll with it. You never have to deal with failure if you have the power to undo it immediately. That, to me, is one of the biggest shortcomings of this amazing tool. What may seem like help (the training wheels that I mentioned above) may turn out to be a hindrance the more you use it.

☆ The stroke you intend to make on a tablet and the actual result are not always a match. Some drawing apps (see "The Best Drawing Apps Out

There," page 76) are only accurate if you adjust your stroke, which feels contrived.

☆ To some, the addition of layers takes away the spontaneity and perhaps the genuineness of a drawing. Some might regard this type of "technical assistance" as cheating. Being able to add layers upon layers and to hide some is the tablet equivalent of Photoshopping a photo: it becomes more about the app mastery skills than the drawing skills themselves.

☆ The surface of the tablet, although it is utterly smooth, "grabs" the tip of a stylus, and there is no escaping that fact. It is nothing like the glide of a pen on a piece of paper, even with tooth. That can be a hindrance for crosshatching, or for any strokes you intend to make with a certain amount of speed.

☆ Pressure is irrelevant with a cheap stylus or your fingertip. All the subtleties of the regular pen or pencil are gone. There is only one type of pressure on the tablet, and the only way you deal with values is by changing the opacity of the pen or pencil you are using. It makes for a bit of confusion at first. You will adapt, but you lose the benefits of pressure entirely—which, at least for me, is where a lot of the fun of drawing lies.

128 GB.

## STYLUS VERSUS FINGERTIP

I first began drawing on my iPhone with just the tip of my finger. While it worked, in retrospect, I realized the stylus is a lot friendlier than a finger for drawing on any tablet. The first reason is the size. You also get more accurate strokes with a stylus than you would with the tip of your index finger. When the tip of the stylus lands on the tablet, you are more able to tell where the line is going to be than you would with your fingertip. Also, holding a stylus is like holding a pen; therefore, your wrist and hand go through motions similar to those of drawing on paper. You immediately enter a familiar zone when you hold your stylus for the first time.

That being said, I have yet to find a stylus that has the same ease of movement on the surface as my own skin. The rubbery tip of the stylus grabs slightly more than the fingertip would. You may also find that you are missing something, a direct contact with the tablet perhaps, when you use a stylus. Also, the stylus tip is not like that of a pen or a pencil, so make no mistake, it is not perfect. The tip is rounded, not pointy. That lack of initial accuracy, even with a stylus, might be a tad frustrating. My suggestion is to try a few drawings with both—your fingertip and the stylus—and get a feel for what works better for you.

## THE BEST DRAWING APPS OUT THERE

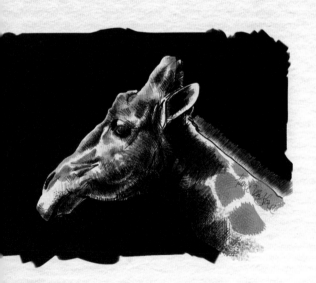

These are the apps for drawing that I recommend.

### Brushes

When I first drew on my iPhone, I had just purchased the Brushes app for less than $5.00. It is very instinctive and easy to use on both the iPhone and iPad. I was never able to overcome the fact, however, that the very first stroke I make with the Brushes app never registers. It's like a pen that has run out of ink for a second. Past the initial faulty stroke, however, it works and offers a great range of possibility: strokes, widths of strokes, and colors.

Even though the Brushes app offers a plethora of brushes, colors, and other shading options, I have used Brushes like I would a piece of paper: I tend to stick to one type of brush and keep my color palette limited. Only toward the end of the giraffe (left) drawing did I start experimenting with "spraying" brushes to create shades—see the underside of the neck. Despite the possibility of drawing in layers, I have never used that feature in Brushes.

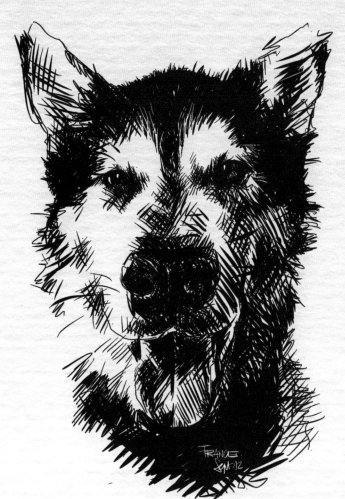

Tonka. *Paper app for the iPad.*

Chris Christie. Procreate
app for the iPad.

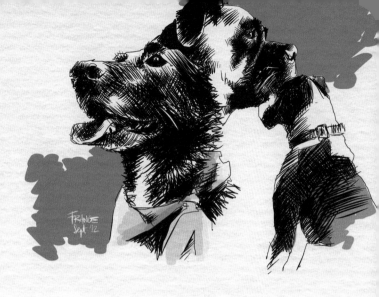

## Procreate

Unfortunately for Brushes, along came Procreate. Procreate is so much more, and above all, it allows for faster speed. Where Brushes sometimes has difficulty following a curve, Procreate delivers smooth, real-life lines. It is the same price as Brushes but you can add features along the way.

Because of my lack of experience in digital and computer arts, I still treat any app, even the amazing Procreate, like a piece of paper instead of a series of layers. I did many drawings with Procreate without using layers. But once I started playing with them, I realized what I had been missing. Oh the joy of being able to experiment on a drawing without running the risk of messing it all up! A *layer* is like a transparent sheet that you draw on. You can erase things from it or delete the entire layer itself. Either way, you do not compromise what you've drawn before. I feel a bit sheepish using layers, because, as I stated earlier, they do not force one to deal with irreversible mistakes; that is why I rarely use them. Layers are a great tool when you can't afford to screw up, or when you are more concerned with delivering a final drawing than the painstaking process of producing it. Endless layers make for endless possibilities.

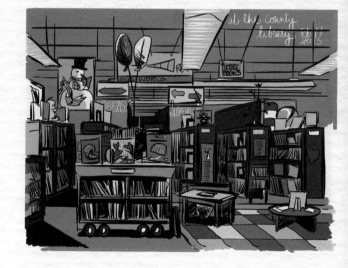

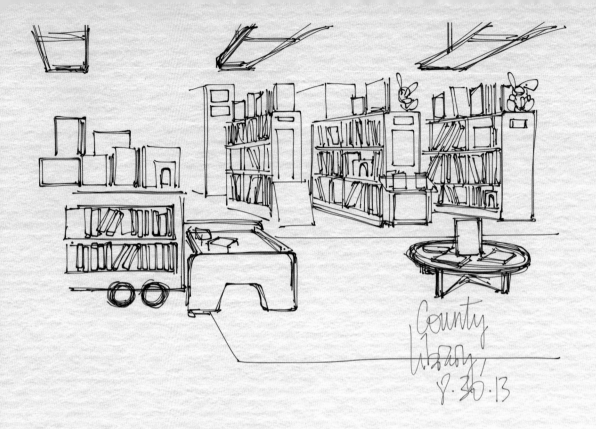

County
Library
8.30.13

## Paper by FiftyThree

If you want to keep it simple and not be encumbered by an unlimited number of stroke possibilities in a beautiful interface, Paper by FiftyThree is the perfect app. You can keep your sketches organized in different sketchbooks (which you open and close with a tap of the finger) and create as many as you wish. The app offers five different types of strokes: a fountain pen, a pencil (which I seldom use, because of the lack of translation of pressure on the tablet), a ballpoint-like pen, a marker, and a watercolor brush. It doesn't have a layer feature, and it doesn't allow for photos to be imported in a sketchbook, hence the name Paper. These very limitations are what I like best about this app and are the reason why I use it the most out of the three I have downloaded onto my tablet. The "undo" feature is also the neatest of them all: you place two fingers on the tablet and move counterclockwise. This particular feature is less disruptive than tapping a little backward arrow at the bottom of the screen. It allows you to stay with the flow of the drawing. While the Photoshop-like features of Procreate are nothing short of mind-blowing, Paper is the app for the sketcher who wants to whip out a tablet and have quick access to simple tools. It is free, and you pay $1.99 for each feature you add.

The following were drawn using the Paper app for the iPad. As with my drawings on paper, I start with black lines and add color last.

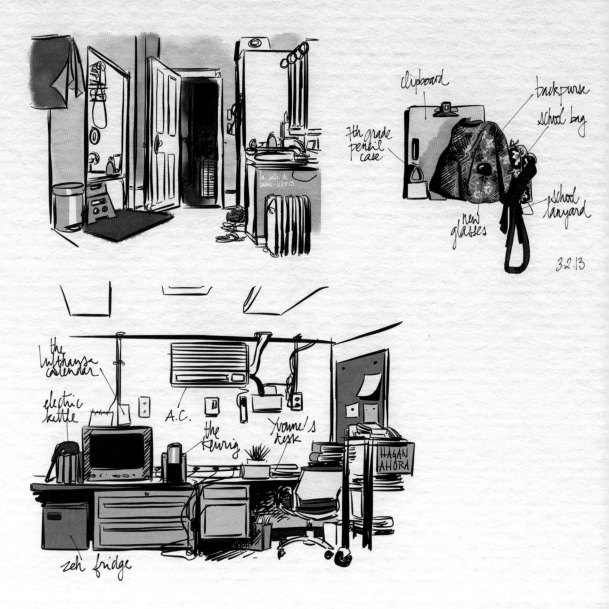

The release of the Pencil tool (the stylus made by FiftyThree exclusively for Paper) brought even more attractive features to the Paper app, making it my favorite tool for drawing on the iPad.

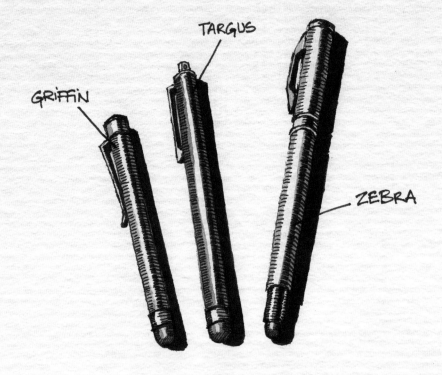

GRIFFIN

TARGUS

ZEBRA

# THE STYLUSES I USE

I started out with styluses that you can find in any store carrying office and electronic supplies: all had a fairly wide, round tip that cannot be replaced when it breaks. Tips do break with use; the constant rubbing against the surface of the tablet wears on tips to the point that the thin rubbery nib cracks.

The first stylus I bought, not knowing there were styluses out there that were made solely for the purpose of drawing, was a short Griffin stylus because of its size. I wanted to be able to put both my smartphone and my stylus in my pocket without anything sticking out. The nib was not slippery, it grabbed the surface as I tried to draw, but I did not know any better.

I then bought a Targus because of the little loop on top, which allows me to carry it at the end of a lanyard. Both styluses—Griffin and Targus—have similar tips, shape, width, and feel. They are rather wide.

I was then offered a Zebra Z-1000 stylus/pen combination, which I carried in the holder of my iPad case. While I never used the pen side of the contraption, I found the length, weight, and tip size to be comfortable. The tip was significantly narrower (0.5 mm) than the two previous styluses, and that allows for a little more precision.

All styluses mentioned above range from $8.00 to $15.00.

Everything changed after I decided to spend $40.00 for my first Wacom Bamboo. The moment the nib made contact with the surface of my iPad, I understood why some friends swore by them. The nib rubber, while soft, has a more slippery texture, allowing the stylus to glide in ways the previous, cheaper styluses could not.

While it didn't offer any of the pressure sensitivity I was starting to read about on the web, the Bamboo has been perfect for the use I have had of it. Second generation Bamboo styluses feature an even narrower nib, allowing for even more accuracy.

In November 2013, the makers of the Paper app, FiftyThree, released Pencil. And once again I found an even better tool. However, all the options that Pencil offers are confined to the Paper app itself. You will not be able to enjoy those

features if you use Pencil with any other app. Outside of Paper, Pencil behaves like a regular stylus. But once connected to Paper, which is known as "kissing," Pencil includes some wowing features:

☆ Palm rejection. This is the most incredible feature of all: it allows you to rest your hand on the tablet while you draw (if your hand will not register on the screen). Only the lines you draw with the nib of Pencil will be visible.

☆ Blend. Depending on how you choose to set up Pencil, you can opt to have your finger blur what you draw.

☆ Dots. If you let the nib of the Pencil linger as you make a dot, the dot will grow larger. The quicker the contact, the smaller the dot.

Pencil comes in two colors—walnut or graphite—the former allows it to attach to your iPad Smart Cover with a magnet. Because it works with Bluetooth, it has to be recharged. But so far, after hours of daily use, I have only had to recharge it once a month. Visit www.fiftythree.com/pencil for all the technicalities. The walnut Pencil costs a little less than $60.00.

In the space of a couple of months, I went from not knowing about made-for-drawing styluses to owning three without which I cannot draw today. These three are the Bamboo, Pencil by FiftyThree, and the Adonit Jot Touch 4.

The Adonit Jot Touch 4 is a $90 pressure-sensitive stylus. It can be paired with Procreate via Bluetooth, and wild as it may sound, the marks on the tablet will respond to the amount of pressure you apply. The thin, precise, "just-like-a-pen" end of the Adonit Jot Touch 4 allows for better precision. You actually see exactly where you make a mark, thanks to the see-through little discus at the tip. I have read reviews complaining about the "clicking" sound that the tip makes when it comes in contact with the surface of the tablet, but it hasn't bothered me.

Depending on what app you use, the Adonit will also enable palm rejection. Since I have used my Adonit Jot Touch 4 with Procreate, palm rejection has not been an option, but the pressure sensitivity is a boon.

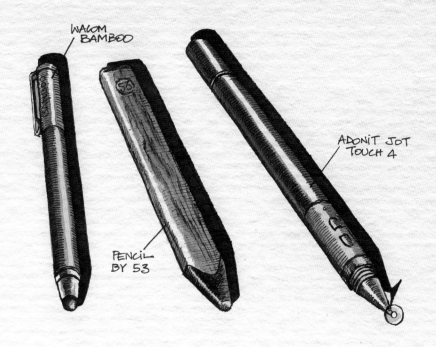

WACOM
BAMBOO

PENCIL
BY 53

ADONIT JOT
TOUCH 4

Say the need or the want to draw strikes. Because the mere action of digging in a bag for a stylus can be disruptive to the point of becoming an obstacle to drawing, I have kept my new styluses around my iPad with an elastic strap. That neat little contraption is called a "bandolier" and they can be found at www.etsy.com/shop/cleverhands.

## DRAWING ON A SMARTPHONE

The following sketches were done on my iPhone with a Brushes app. I did these before I had an iPad or a stylus. The small size of a smartphone makes sketching on one a challenge, but it can yield interesting results. See the next page for more on this process.

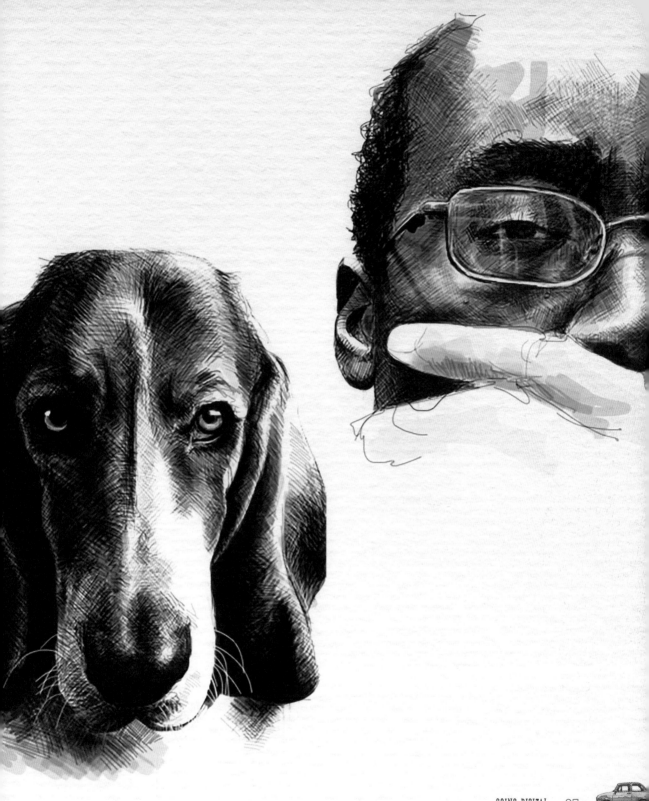

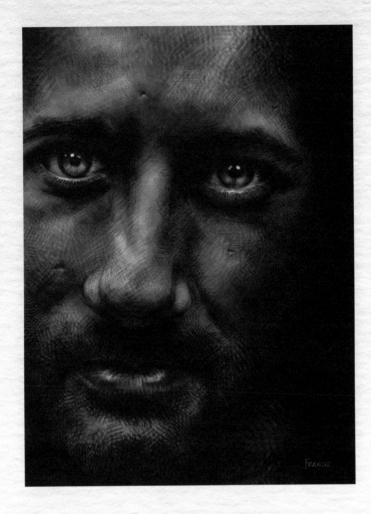

This particular drawing took hours.

I was at it for several evenings, zooming in and out constantly to see every stroke I was making with my fingertip as well as the whole picture. Drawing on such a small surface as the iPhone is sheer penance. Once I got my iPad, I knew I would never attempt something so tedious again.

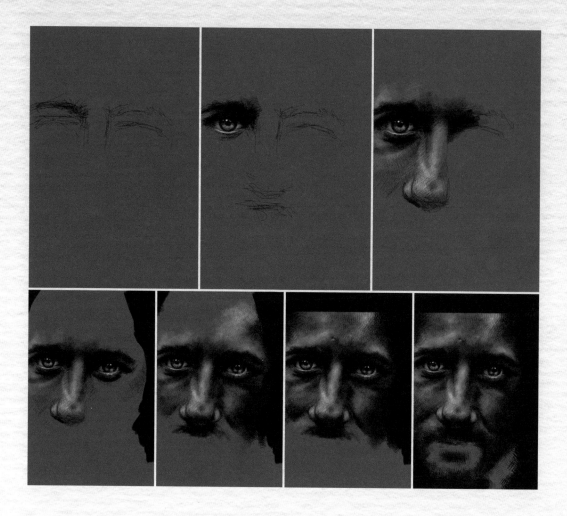

Drawing digitally offers endless possibilities in terms of layers, strokes, and colors. At the end of the day, however, the pleasure I derive from drawing lies in being able to play with pressure (be it with a pen or a pencil) while keeping my supplies minimal. When the tablet is able to recreate that experience accurately across all apps, it will truly have replaced the sketchbook. But as far as I am concerned, we are not there yet. So let's not regard the tablet as the possible replacement to paper. It is a fantastic addition, and a great tool to practice with if you feel a tad intimidated by a blank sheet of paper. I highly recommend it, but you might have to go through several styluses to find the one that suits your tablet needs best.

# CHAPTER 6
# PROMPTS

Your sketchbook is handy, you have a pen, but the one thing missing is inspiration. Sometimes you need a little cheat sheet of prompts to kick-start your drawing.

Your world is all around you, but where to begin? How about with the letter A?

## A IS FOR . . .

### Animals

Whether it is a fast sketch or a more elaborate drawing, an animal is always an amazingly complex subject to tackle. To me, they are the best practice for people portraits. Capturing the features on the face of a giraffe or a dog is not unlike the exploration of the human face.

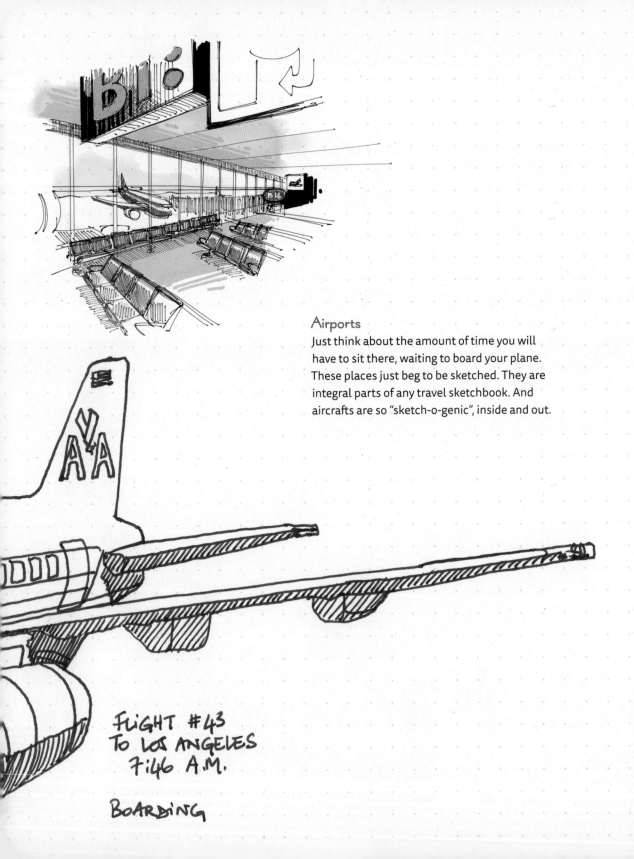

## Airports

Just think about the amount of time you will
have to sit there, waiting to board your plane.
These places just beg to be sketched. They are
integral parts of any travel sketchbook. And
aircrafts are so "sketch-o-genic", inside and out.

FLIGHT #43
TO LOS ANGELES
7:46 A.M.

BOARDING

# B IS FOR . . .

### Bags

This is probably one of the items that I have drawn the most over the years. Just like keys, bags are usually with you, and if not your own, you can draw someone else's. Draw your bag from above while it's on the floor or on a chair next to you. Draw your bag at eye level, as it sits on the table, and you slouch in a chair. Draw your bag open or closed. Draw totes, purses, backpacks, attachés, string bags, plastic record-store bags, dog carriers, luggage, and grocery bags.

TAYLOR

ABDUL

SIDDARTH

MAXWELL

PRIYANKA

## Bananas

Andy Warhol and the Velvet Underground should not deter you from trying your own spin on bananas. As with hats, bananas are things whose shape we think we know but have to refrain from drawing the way we believe they are, or we will draw yellow moons.

# C IS FOR . . .

## Cars

I guess it takes a certain affinity for cars to enjoy drawing them. At least this is the only way I can explain having drawn so many since I was a kid. I wish I had enough time to sit and draw them on location; that is why most of those I draw come from pictures. To some, drawing from photographs is blasphemy, but not to me. You do what you can with the means you have. For instance, I have never seen a Morris Minor in real life, but I have drawn several.

Older Japanese models, when they first appeared on the American market, like the first Hondas, Toyotas, Datsuns, and Subarus, are among the most beautifully designed cars. But my personal all-time favorite is the late eighties Volvo 240 wagon, which I was lucky to own once.

FRANCE.

## Chairs

For such a common object, a chair can be tricky to draw. And that's why you should have as many chairs covering the pages of your sketchbooks as you can: chairs in waiting rooms, chairs in your dining room, chairs stacked, office chairs, armchairs, reupholstered armchairs, seats, chairs upside down, broken chairs, and padded chairs. And even if you were to only have one chair around you your entire life, a different angle can turn it into a whole new object.

CHAIR
UPHOLSTERED
BY TOM
(WITH PIECES OF
CLOTHING, AMONG
OTHER THINGS)

MY LITTLE AMP
(BIRTHDAY GIFT) WITH
A COASTER ON IT
(A DRINK ALWAYS HELPS
UNLOCK THE PATTI SMITH
IN ME). HA.

I HAD ALREADY STARTED DRAWING THE GUITAR WHEN **MARVIN** DECIDED TO LIE HERE. NOW HE LOOKS LIKE A GHOST CAT.

## Cups

Cylinders (or anything remotely cylindrical) is the best practice for one of the hardest shapes to draw: ellipses. Depending on whether you are looking down, facing, or looking up at a cup, the curves will be rounder or flatter.

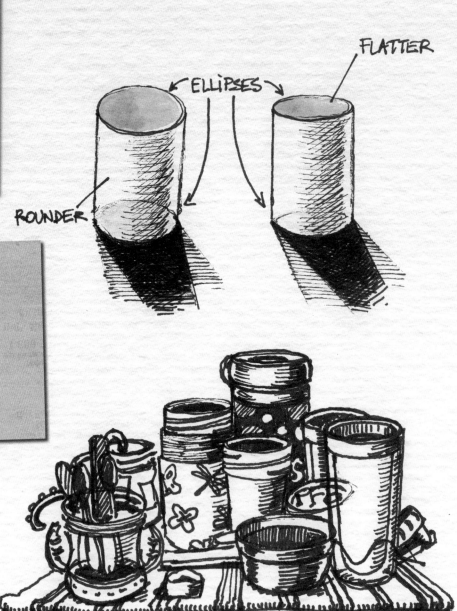

FLATTER

ELLIPSES

ROUNDER

# D IS FOR...

### Desk

It should be a messy desk, preferably. Step back, grab a chair, look at your desk. Look at a colleague's desk. There is a lot there to draw, even if the desk is clear of clutter. It will be full of seemingly unattractive features, like the wires of a computer.

I do not draw to glamorize my everyday life. Its own lack of glamour appeals to me. The back of a PC is so ugly, it is fun to sketch. Have you looked at the computer you have to use at work?

Do you work surrounded by public school furniture? Have you fully grasped the design blandness of Steelcase desks?

If I was waiting for my surroundings to be exciting and inspiring in order to draw them, I would seldom open my sketchbook. The Douglas Coupland–esque environment in which I work every day does not deter me from laying it down on paper; on the contrary: celebrate dullness, I say.

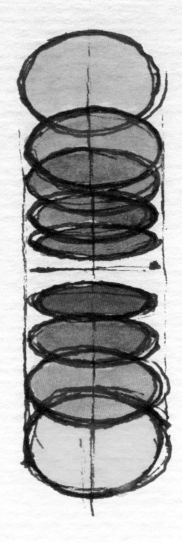

# E IS FOR . . .

## Ellipses
I can draw them over and over and still feel as if it is the first time I have drawn one. They are just obnoxiously elusive.

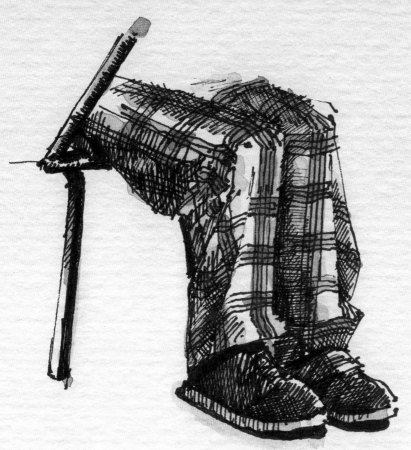

## Excerpts

You can draw something in its entirety or you can opt to sketch an excerpt of it. Just isolate a piece and focus on that: a piece of a bag, someone's pants, a detail of a car, a corner of a building, an ornament, the frame of a bike.

# F IS FOR . . .

## Faces

I was once told that you should draw a face as you would a landscape, not worrying about whether you are doing a nose next to a cheek next to an ear, but rather a curvy thing here and a rounder shape there, all in relation with one another. I believe it is indeed a great way to override what your left brain is going to inevitably want to do, and that is tell you what a nose, a cheek, or an ear should look like. I suggest going all out at first and drawing faces with a pen. Be unapologetically wrong about your proportions at first. But what you should try to convey, no matter what, is what you see. One thing you will find out is that eyes are rarely white near the pupil. Also, the bottom of the eyelid will most likely not show, so resist the temptation to draw a thick line underneath the eye. Stay mindful of the volume of the skull at all times. There are lots of mountains and valleys on those faces of ours.

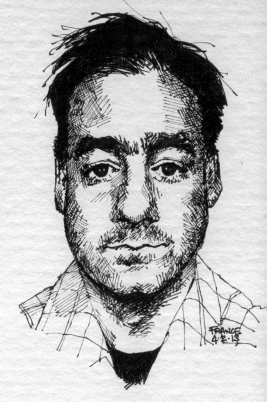

Draw strangers. Do not worry about resemblance. Pay no mind to those who say "it doesn't look like him." Keep drawing. If we wanted perfect resemblance, we would have whipped out an SLR or would have used one of those "turn any photo into a pencil drawing" apps. You will have plenty of time to be preoccupied with resemblance if you get commission portraits. Right now, draw strangers. Find faces in magazines and draw them. Find pictures of old people and draw them. Finish or not. Do only half if you don't have the time.

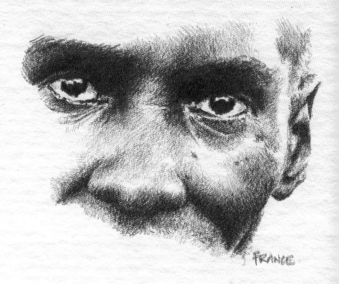

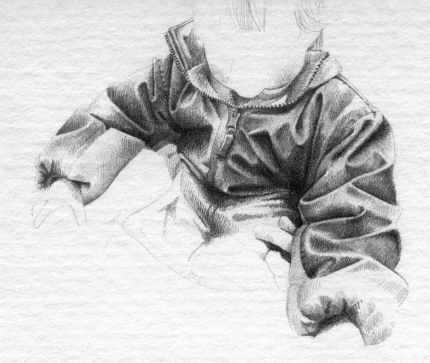

## Folds in Fabric

How to render folds on fabric is one of the many techniques I have gleaned
from looking tirelessly at sketches of Michelangelo and the paintings of Ingres.
Search for Princesse Albert de Broglie and delight for a while at how the light
hits the fabric of her dress. Because that's what drawing folds forces you
to do: know where the source of light comes from, and how to refrain from
crosshatching too much so as to let the light show. Try pants, socks, and jackets
in pen or pencil, because in my mind, they are equally as tricky. You can even
draw the head of a sleeping baby in there.

# G IS FOR . . .

## Glasses

I now have to wear glasses for driving. This is another object that is deceptively simple but full of asymmetry once you start drawing it. Unless, of course, you choose to draw a frontal view of a pair of eye glasses.

Look at the cool little shadows glasses make on the table and draw those, too.

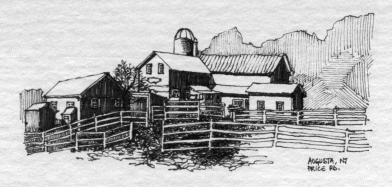

AUGUSTA, NJ
PRICE RD.

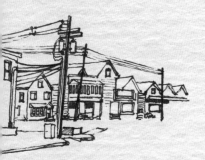

# H IS FOR . . .

## Houses

You may or may not live in a house. In fact, I wouldn't use my own house as the first drawing of a house I would ever do. It's almost like drawing a person's features: you're better off starting with a stranger, as your own knowledge or someone might interfere with your actual perception of their physical traits. Stop on the side of the road, sit on the sidewalk, and draw.

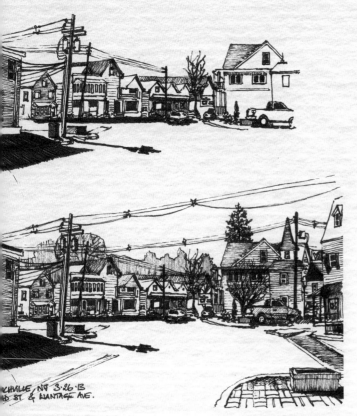

NICHVALLE, NJ 3·26·13
D ST & VANTAGE AVE.

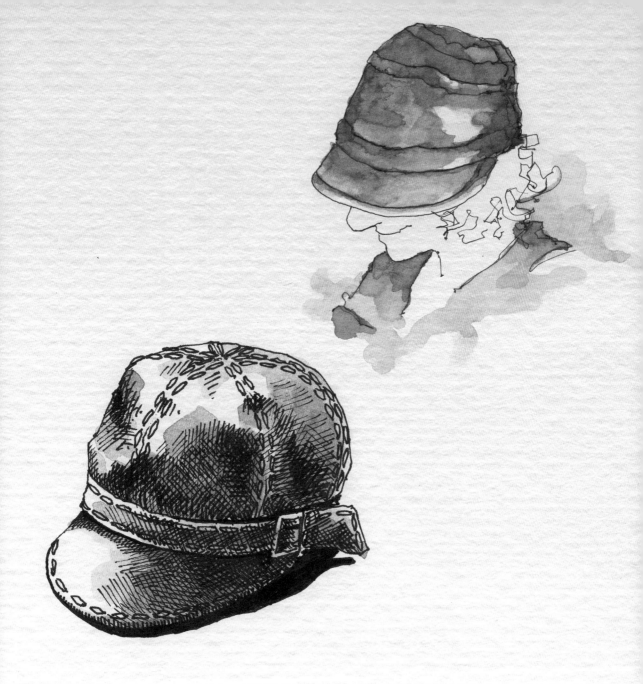

## Hats

A hat will force you to "unthink" the way you think it should be drawn. You have to focus on what you see rather than on what you believe a hat to be.

RED

## Hallways

A great way to draw perspective lines without having to step outdoors is to draw hallways. They may look barren when you just look at them, but when you sit in the middle of one and start sketching, don't be surprised to find a lot of little nooks and imperfections.

## Hands

If you are up for a challenge, the kind that can keep you glued to the paper for hours, draw your hands. Draw them from life or in a mirror. You can even draw them from pictures so you can have more unusual angles. Practicing drawing hands, whether quickly or with more detail, is as frustrating at times as it is rewarding. There is so much intricacy to render that you will have to force yourself to see like a sculptor. Any sculpture by Rodin or Michelangelo will show you how difficult it is to render the three-dimensionality of hands.

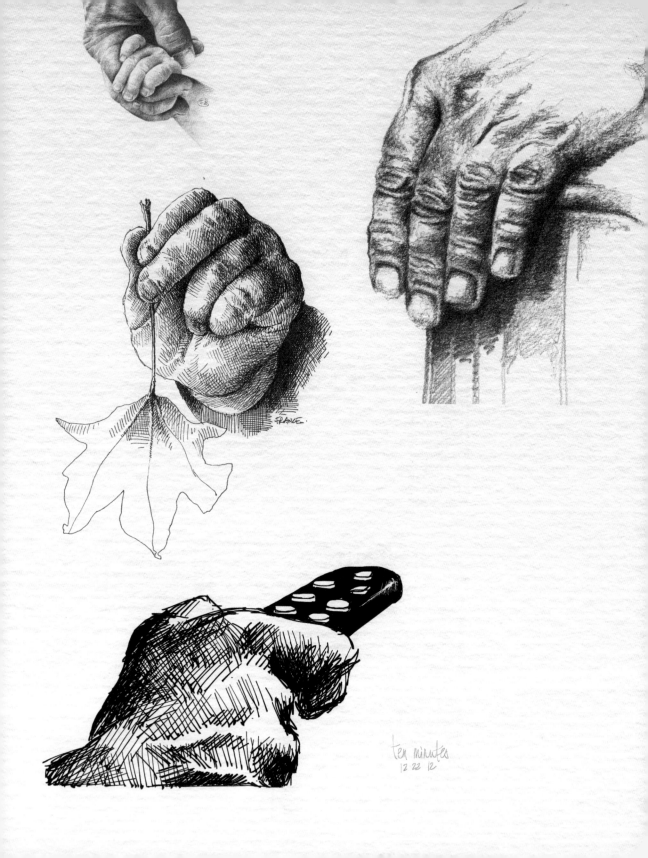

FRANCE

ten minutes
12 22 12

# I IS FOR . . .

## Inventories

Choose a theme and draw everything that can fit in it: the contents of a care package ready to be shipped, tools, your place room by room. The person who inspired me to start making little inventories is Gregory L. Blackstock, an autistic artistic savant. His work will astound you.

# J IS FOR . . .

### Joined

Which is another way to say superimposed or overlapping. Letting your sketches overlap on a page is another liberating aspect of being the master of your little sketchbook. You have free rein. Let the drawings go where they will. Here is an example of a quick study I did of my friend and colleague Sue. I was not doing a formal portrait, but trying to capture her "Sue-ness" so to speak, in pencil.

PORTE DE MAMAN

PORTE DE PAPA

FRANCE 2·2·13

NORA HAS ASSIGNED DOORS:
THE DOOR TO THE BACK PORCH
IS HERS. THE DOOR TO THE
FRONT PORCH IS "MAMAN'S"
AND THE DOOR TO THE
BASEMENT IS "PAPA'S".

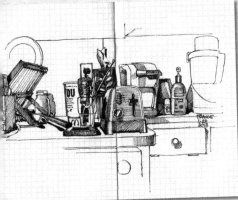

# K IS FOR...

## Kitchen

The kitchen has been central to the life of our little family: this is where we cook and wash dishes, but there's also a little crafts table, windows, an ironing table, and six doors . . . and a serious water leak. And because drawing fits in the flow of life, the kitchen is perfectly suitable for sketching. Every angle offers a drawing opportunity. Whether you open the fridge or the pantry to draw its contents, draw the dirty or the clean dishes, keep your kitchen island clear of clutter or buried under the day's shuffle, the possibilities are endless.

## Keys

Draw your keys. Even if all you live with is one key, draw it: in different angles, in different contexts, in color or black and white, up close or from a distance. Keys are so "sketch-o-genic." And most likely, they are always at arm's reach.

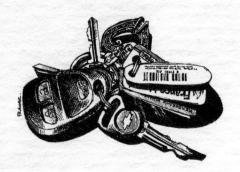

# L IS FOR...

## Living Room

If I can stay awake long enough to do a quick sketch from the couch in the evening, let it be a sketch of the room. I usually start with the TV and work my way around. How will you start yours?

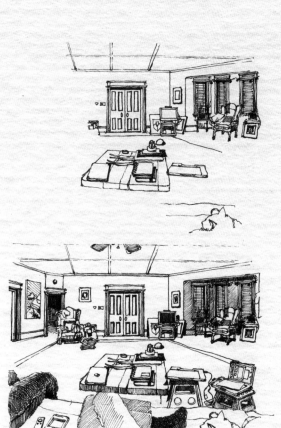
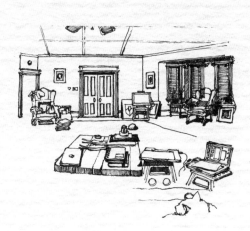

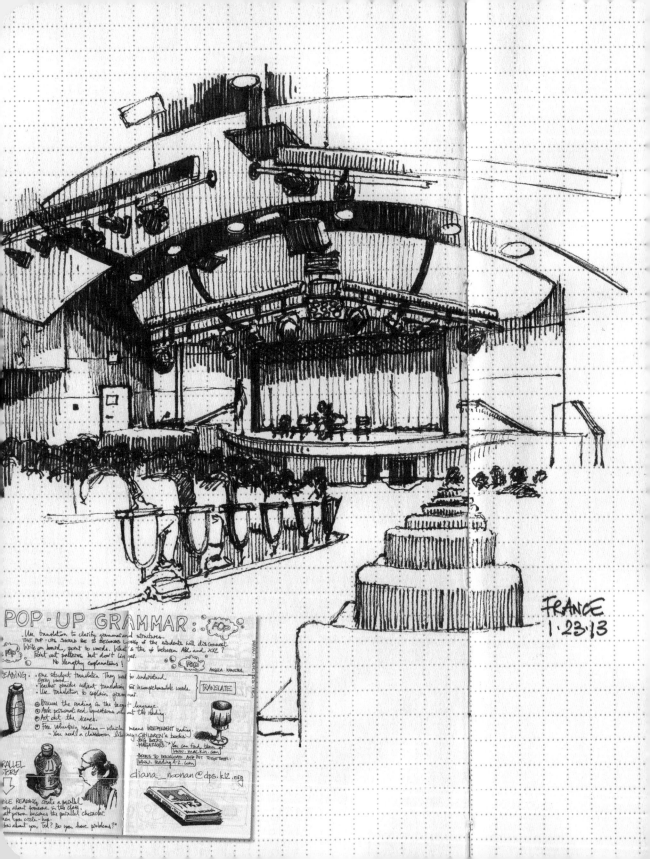

FRANCE
1·23·13

POP-UP GRAMMAR: POP

Use translation to clarify grammar and structures.
THE POP-UPS SHOULD BE 5 SECONDS LONG or the students will disconnect.
Write on board, point to words. What's the ≠ between ABC and XYZ?
POP Point out patterns but don't linger.
No lengthy explanations! POP

POP
ANGELA KANCETA

www.wallplans.net

READING. • One student translates. They need to understand
every word.
• Teacher provides instant translation for incomprehensible words. TRANSLATE
• Use translation to explain grammar.

① Discuss the reading in the target language.
② Ask personalized questions about the reading.
③ Act out the scenes.
④ Free voluntary reading — which means INDEPENDENT reading.
— You need a classroom library: CHILDREN's books · BIG BOOKS
· MAGAZINES. You can find them at
www.mackin.com
· BOOKS TO DOWNLOAD AND PUT TOGETHER:
www.reading A-Z.com

diana_noonan@dps.k12.org

PARALLEL
STORY

WHILE READING, create a parallel
story about someone in the class.
a1 person becomes the parallel character.
... you circle-hop.
How about you, Ted? Do you have problems?"

# M IS FOR . . .

## Meetings

If your professional life involves attending meetings, don't forget to go with your sketchbook in your hand. These sketches are somewhere between doodles and recording. These are great opportunities to sit in the back of the room and practice drawing while focusing on your subjects, blind-contour style, rather than on the paper. There is no time for composition, just for capturing people who tend to move. And if you arrive early at the meeting, sketch the lobby! I believe there is a huge benefit to drawing while listening to someone making a presentation, and this is why I rarely stop my students from drawing during class. I attended meetings that my husband couldn't attend; to tell him what was discussed, I had to go back to my sketchbook to see what I had drawn. Looking at the drawings was like replaying what had been said.

My meeting doodles often feature my colleagues from the back, which of course is a way to draw people without having to burden myself with their facial features (and therefore mess them up). In other words, these are some pretty cowardly sketches from a "let's venture out of our comfort zone" point of view!

There is also the option of avoiding people altogether and just drawing the venue.

I have also attended numerous workshops during which I had to take notes, but I could not help drawing among the words. There is a phenomenon out there called *sketchnotes*. Some of the sketchnotes showcased online make mine look like they are in their infancy. Attending hours of PowerPoint presentations annually is an integral part of the teaching profession, and I have only started to explore all the ways I can translate what happens during those presentations to paper. Getting better at sketchnotes is a goal of mine.

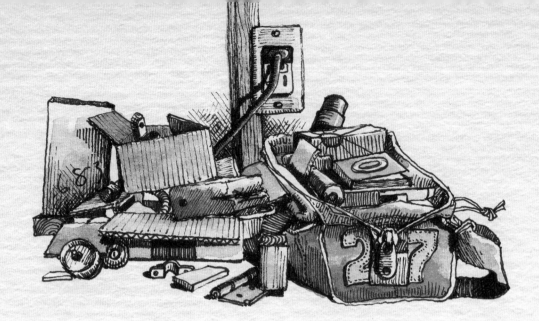

## Messes

We wouldn't be drawing our true daily lives if we bypassed the messes we or other people leave on tables, would we?

If it weren't for how messy my workplace and my home are, I wouldn't draw half of the time. Why are messes great to draw? They offer complete randomness and features that I particularly seek when I draw: lots of little or big things together. The garage is the ideal place to find a guaranteed mess, but sometimes you may not have to look much further than your coffee table, especially if you have a kid around.

The "building" of the sketch of a mess always starts with a little detail, usually an object that is unobstructed, and I build around it. Desks full of stuff are most appealing, because the mess will change from one week to the next, offering endless inspiration. Other people's messes are always more comfortable to me; since I don't need to clean up, I am freed up to draw.

# N IS FOR...

## Necks

This is what you end up drawing a lot when you sit in the back of a room and use the people in front of you as your subjects.

# O IS FOR...

## Ocean

I have only ever sketched the ocean in black and white. I bring my sketchbook to the beach and let sand get in the gutter. Drawing the ocean is an exercise in restraint; in other words, it is the opposite of drawing a mess on a table.

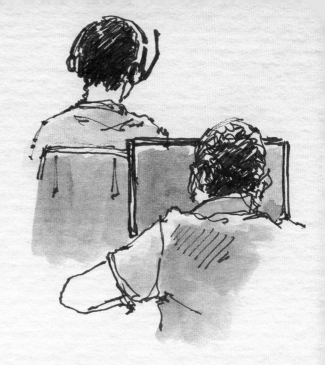

LBI

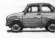

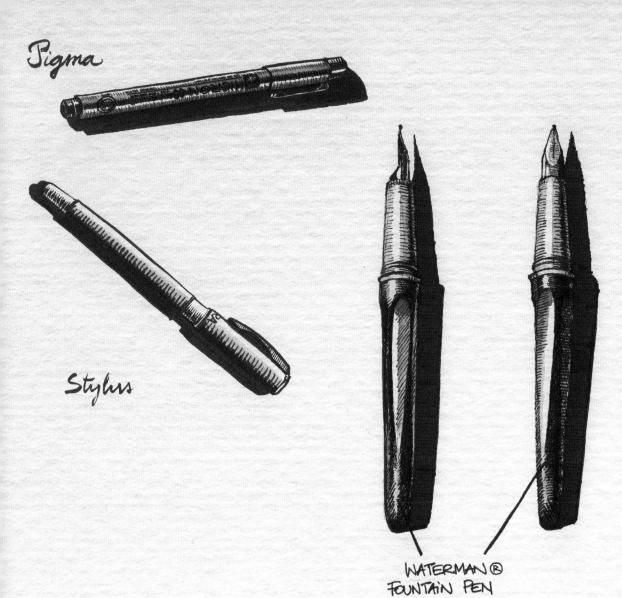

*Pigma*

*Stylus*

WATERMAN®
FOUNTAIN PEN

# P IS FOR...

### Pens and Pencils

Drawing what you draw with is probably a rite of passage in the growth of a sketcher. While my ability to draw my supplies will never equal the work of Andrea Joseph, I keep drawing them. What would I do without them? You can also draw inventories (see page 112) of them.

# Q IS FOR . . .

## Quasi Drawings

These are the drawings you have to accept and from which you can move on. My sketchbooks are full of them, and it would be disingenuous of me to claim they do not affect or frustrate me, even today. So here are a few atrocities. In the first one, I missed the perspective, as if I had missed a turn, and the shower got stuck there. I had to drop it there and start a new one.

For the 1962 Buick Invicta, I do not know what came upon me and made me think I could sketch a car on such thin paper with such a thick pen. I hated it within minutes, but thought that somehow I could make it work.

There are also times when it just does not come together as a drawing. It's just a bunch of lines that do not seem to want to get along and cohere. This is a perfect example of something pretty innocuous in shape: a rectangle. I should stay away from plastic and think I can render it with an overload of watercolor.

I go out optimistically with my fold-up chair, thinking I am going to sketch my town and end up with an unfortunate palette of colors, wrong proportions, and a big yellow mark on the street right in front of me.

Note that I do not include blind contour drawings, which are visual catastrophes by definition, because I do not regard them as failures. They are tools.

Though if you look at it from the right perspective, all quasi-drawings are tools—tools by which you learn to improve.

# R IS FOR . . .

### Restaurants

Second on the list (after airports) of places where you are bound to wait, restaurants are perfect spaces to draw with minimal disruption. I used to feel tentative about going to a restaurant by myself, but I have done it so much that it does not faze me in the least now. I love sitting at a table and drawing.

# S IS FOR . . .

## Scissors

Do you have a pair nearby? Go get them. Get your kids' scissors if you can't find your own. Look at them. Look at how "sketch-o-genic" they are. The curves, the straight lines. Where the light hits. What happens when you look at them straight from above. What happens when you lower your gaze and you see the foreshortening effect of the perspective. Open them, and they almost become another object. They are fascinating to draw, vertically or horizontally, in groups or alone. I love scissors.

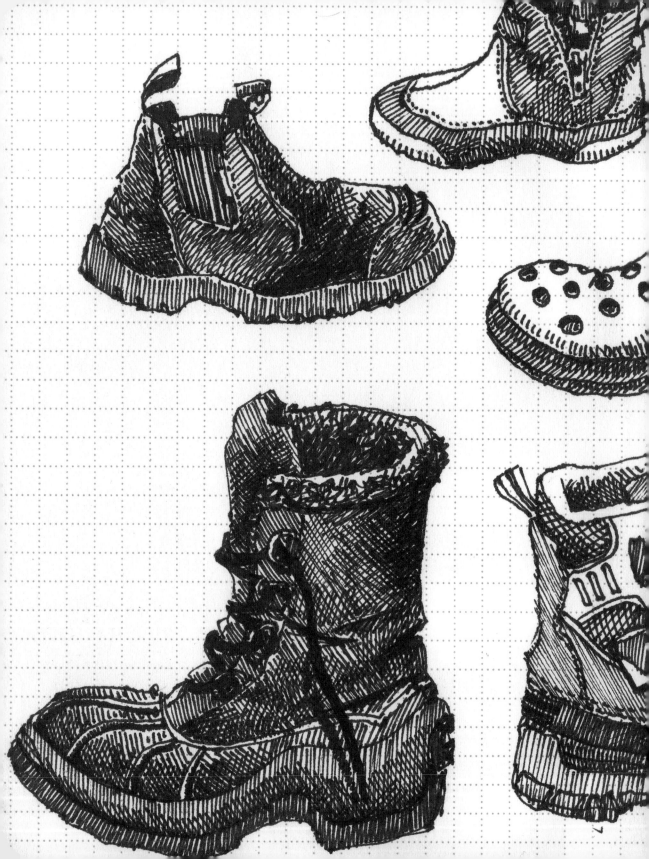

## Shoes

Baby shoes, work shoes, sneakers, the shoes lying around the entrance door, brand-new shoes, boots, sandals: I cannot think of a shoe I did not have fun drawing. They are everywhere and they are intricate. As we did with cups, look at them from above or put one on the table (on a paper towel, of course), and draw away. Use pen or pencil. You will not tire of drawing shoes.

I have not kept my daughter's first shoes, however cute these little size 5 shoes were. Instead, I recorded them on paper.

# T IS FOR . . .

### Tambourines

This entry should say "Trees." Go and draw trees. I just have not yet been successful drawing them: I have yet to figure out how to deal with the foliage so I do not get overwhelmed in the middle of a drawing. Trees and nudes (figure drawing) are on my to-do list. In the meantime, I draw my daughter's tambourine.

# U IS FOR . . .

### Useless

Draw useless things before you part with them for good. Then you will not have to hold on to them.

FRANCE.

FRANCE

# V IS FOR . . .

## Vegetables

I have struggled to render the shape and volume of peppers. To this day, I have not found an easy recipe to capture that vegetable on paper or digitally—its shape is always elusive to me, no matter the angle. For the dozens of potatoes I have sketched (see page 16), there is only a handful of other vegetables I have laid down on paper. There is something unmistakable and honest about the shape of a potato. Even a badly-drawn potato will most likely be recognized and therefore yield a feeling of satisfaction in the person who drew it. Peppers offer no such gratification. They demand labor, and after you have finished sketching, you are not guaranteed to be happy with the results—far from it. In other words, draw more peppers.

# W IS FOR . . .

## Workspace

There is the workplace, there is work, and there is our little corner of the world, where our stuff belongs. Mine has been pretty much the same for years, whether I lived in the United States or abroad: a five-foot plank of Formica on trestles, with plenty of space for drawing, spreading papers, and scanning. In front of my desk, hanging on the wall, I have a sign that I had found in Brussels, which reads, in Dutch:

"Whether you paint, sculpt, create, experiment, paint watercolors, make ceramics, make calligraphy, one thing is for sure, you make ART."

# X IS FOR . . .

### Xylophone
I personally have never had a chance to draw one. A walk down to the band room at my school is in order.

# Y IS FOR . . .

### Yourself
This is a big one. One with which I have struggled. I have attempted two self-portraits so far, and they have both ended up making me look like a tired dude. It is as if I am about to be too kind to myself, so I make sure I sabotage my face, lest I should be dubbed vain. Or perhaps what I have drawn is what I look like and I have been fooling myself for the past few decades. Talk about shedding perceptions of myself and truly perceiving who I am.

This is my next assignment.

# Z IS FOR . . .

### Zen
Neighbors of mine have adorned their entire street with little piles of stones: one pile near each home on the street. The only explanation I have for these is Zen. But I may be way off track.

Some pile stones, while others draw.

Ultimately, in drawing your daily life, you are going to find something that you may not have sought from the beginning: a sense of harmony, and perhaps even a sense of belonging with what surrounds you.

Up until recently, I had only stayed in one place for a couple of years before moving. I had no anchor and no constant for a good portion of the past two decades. And while the concept of home is still nothing more than the place where I get mail, drawing the life around me has helped me hang my hat somewhere, and learn to love what that somewhere is.

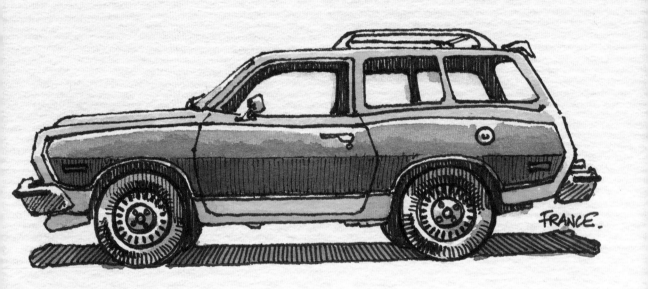

BY MAMAN
NORA

Portrait by the author's daughter.

## ABOUT THE AUTHOR

France Belleville-Van Stone is a high school French teacher who grew up in Montbéliard, France. She developed a fascination with the English language in her teens through Bruce Springsteen, Leonard Cohen, and John Steinbeck. She moved to the United States on a teaching assistantship at Penn State University after finishing her Master's in American Studies at Université Strasbourg II.

Despite not having studied art past middle school, in 2006 she launched a blog of sketches, *wagonized* (in reference to her infatuation with old Volvo wagons), as a means to motivate herself to draw on a daily basis. As a result of blogging, she has had the opportunity to meet and sketch with fellow artists from around the world. Her drawings were featured in Danny Gregory's *An Illustrated Life* in 2008.

She currently lives in an old house in rural Northwestern New Jersey with her furniture-upholstering, pergola-building, ukulele-playing husband and their daughter. She will often be found sketching with a cat on her lap.

Her sketches are documented at www.wagonized.com.

## ACKNOWLEDGMENTS

A big thank you to Lisa Buch for taking me on this adventure.

Raheli Harper, meeting you has had consequences that have ranged far beyond what you could imagine.

To my fellow bloggers and friends, from the early days until now, thank you for your inspiration: Suzanne and Edgar Cabrera, Andrea Joseph, Joan Yoshioka, Danny Gregory, Jurgen Verfaillie, Juj Winn, Paul Heaston, Amanda Kavanagh, Stephen Gardner, Liz Steel, Lapin, Laura Frankstone, Miguel Herranz, Gabriel Campanario, Walt Taylor, Mariana Musa, Olivier Goupil, Ryan Wolf, Ryan White, Wendy McNaughton, and Kathleen York.

Thank you to the team of people who made this book happen: Michelle Thompson for designing the interior; Angelina Cheney and Christina Jirachachavalwong for the cover; and Margaux Keres for helping with the design production.

Thank you to my editor at Ten Speed Press, Kaitlin Ketchum, for being my anchor throughout the process.

Thank you, Tom, for being a super papa while I was typing and drawing away.

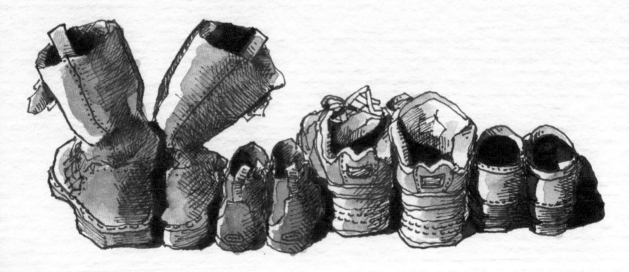

# Index

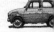